IMAGES
of America

NORTHVILLE

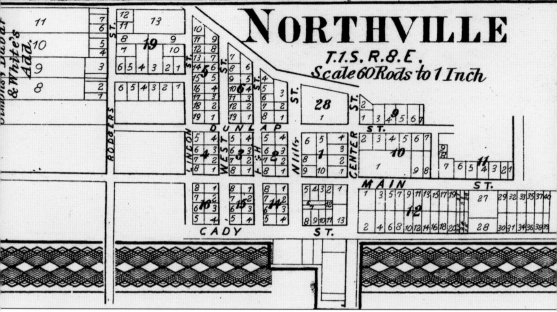

Northville Street Map, 1876. This map from the 1876 Wayne County Atlas shows the Village of Northville. The footprint of the downtown is predominantly the same today. The only notable change is that West Street now ends at Main Street rather than extending through to Cady, as indicated on this map. (Courtesy of the Northville Historical Society.)

On the Cover: I. H. Webster operated the Star Laundry, pictured about 1900, on the north side of East Main Street between Wing and Center Streets. George Northrop owned the building. C. B. Turnbull opened the Northville Electric Shop on the lower level in 1918. The Turnbulls lived above the store. Their son, Bruce, was born in a bedroom in the upper right corner on October 7, 1919. (Courtesy of the Northville Historical Society.)

IMAGES
of America
NORTHVILLE

Michele M. Fecht
Foreword by Mayor Christopher J. Johnson

ARCADIA
PUBLISHING

Published by Arcadia Publishing
Charleston SC, Chicago IL, Portsmouth NH, San Francisco CA

Printed in the United States of America

Library of Congress Control Number: 2009943867

For all general information contact Arcadia Publishing at:
Telephone 843-853-2070
Fax 843-853-0044
E-mail sales@arcadiapublishing.com
For customer service and orders:
Toll-Free 1-888-313-2665

Visit us on the Internet at www.arcadiapublishing.com

*To the photographers, nearly all anonymous and
unaccredited, whose visual storytelling so profoundly
captured the history and identity of Northville*

CONTENTS

Acknowledgments 6

Foreword 7

Introduction 8

1. A Treacherous Trek 11

2. Gristmill Spurs Growth 21

3. Cobblers, Coopers, and Carriage Makers 33

4. The Ideal Suburban Village 45

5. Wheels and Wings 55

6. Lessons, Liturgy, and Leisure 71

7. City Incorporation 89

8. Enlightenment and Advocacy 103

9. Preservation and Perseverance 113

ACKNOWLEDGMENTS

Unless otherwise noted, the images in this book are from the Northville Historical Society's archives, maintained by archivist and curator Heidi Nielsen and a dedicated corps of volunteers. I am most grateful to Heidi for her grace and unflappable nature. She has an archivist's tenacity, always looking "in just one more place" in the hunt for the obscure. I am indebted to her for the time she stole from her schedule to assist me.

The creation and maintenance of Mill Race Historical Village, one of our city's jewels, belongs to the Northville Historical Society. I am thankful to those visionaries—both past and present. It is to their credit that so much of our community's history is preserved.

This history of Northville would not be complete without acknowledging the storytellers, most notably Francis Gazlay and Bruce Turnbull, both in a league of their own as extraordinary gentlemen and exceptional scholars of local history.

There are many fine histories of Northville, including Barbara Louie's excellent *Northville, Michigan* in Arcadia's Making of America series and Laura Smyth Hixson's *Early Northville*. Both were valuable resources. Jack Hoffman's *Northville . . . The First Hundred Years*, now in its fourth printing, continues to be a compulsory read. Former editor of *The Northville Record*, Jack gave me my first newspaper job. My dog-eared copy of his book reminds me of his shared passion for local history and journalism.

That same passion can be found in the centennial edition of *The Northville Record*, printed in 1969 by then publisher Bill Sliger. It is one of the most comprehensive histories of Northville and a gold standard for newspaper supplements. Bill was a mentor, advisor, and friend, and I was blessed to have his guidance and good counsel. I am also grateful to longtime friends Chris Johnson, for putting this project in my hands, and Janet Naughton, for her discerning editor's eye.

Lastly, I wish to thank my husband, Steve Fecht, for his eternal patience, encouragement, and expertise in yet another project I have roped him into. This book is as much his effort as mine.

FOREWORD

Northville. This wonderful place has been my home since 1968. I remember the date—October 10, 1968—because my parents closed on the house the day that the Detroit Tigers won the 1968 World Series.

Northville is a community that has a strong sense of its history. Yet a community is made up of many different parts that all have to integrate together in order for the community to thrive and be successful.

I have often remarked to anyone who will listen that one of Northville's strongest assets is its people. Members of this community are volunteers of the highest order. Volunteers can be found serving on our boards and commissions, in our schools, in our places of worship, and on civic organizations that strive to improve our community in many different ways. Like any growing and changing community, Northville is not stagnant. While it has a strong sense of the past and of its history, it also looks forward to its future and the change that time will bring. As the images in this book will show you, Northville has changed and evolved since its beginning. Careful planning and attention to detail by current community members assures us our future will remain bright.

One of the volunteers that I have previously mentioned is the author of this book. Michele Fecht once chronicled Northville school activities while I was on the Northville Board of Education. When the idea for this book came up, I could think of no better person to entrust with this project than Michele. I know that she shares a strong sense of the history of this community and is now an active participant in determining the community's future as a member of the Northville City Council. Her service as the chairperson of the City of Northville's 50th anniversary celebration in 2005 also amply demonstrated her abilities.

Not to be outdone, Michele's husband, Steve Fecht, chronicled the activities of the Northville community for years in his position as a photographer for *The Northville Record* and continues to do so via his photography business, Steve Fecht Photography, located in downtown Northville. His sharp eye and attention to detail assisted in the selection of the images seen throughout this book.

As you view the images here, celebrate with us our robust history!

Christopher J. Johnson
Mayor, City of Northville
February 9, 2010

INTRODUCTION

They came before the railroads, by wagon or steamboat, leaving upstate New York and other Eastern environs to forge a new life in uncharted territory. Arriving in Detroit, where the streets were one continual mud hole, according to pioneer David Clarkson, these early settlers staked their claim in the abundant farmland of Michigan. Though its first land patent dates to 1823, it would be another decade before Northville, some 30 miles northwest of Detroit, or a three-day journey in the early 1800s, would begin to take shape.

In the first half of the 19th century, Northville's settlers created the community footprint with the establishment of mills, a blacksmith shop, post office, and tavern. At the time, Northville was considered a leader in the manufacturing of boots and shoes, with nearly 40 cobblers making footwear for residents of southeastern Michigan. The leather scraps used in boot making were often tossed in the street. During street-paving projects in the late 1930s and early 1980s, those scraps were uncovered beneath the road's surface.

The years following the Civil War were a time of great innovation and prosperity for Northville. The legacy of some of these concerns continues today. On July 15, 1869, Samuel Harkins Little published the first edition of *The Wayne County Record*, later changed to *The Northville Record*. *The Record* still provides news to the community as Wayne County's oldest continuously published weekly newspaper, even 141 years after the publication of its first four-page edition. In 1873, B. A. Parmenter, a Civil War veteran, used his service pension to open Parmenter's Cider Mill. One of the city's oldest businesses, it still draws throngs of cider enthusiasts from throughout the Detroit metropolitan area every autumn.

The manufacturing and industrial growth that grew out of the Civil War brought Northville acclaim. The Globe Furniture Company, started as a foundry in the late 1860s, would become the largest manufacturer of school furniture in the world. American Bell and Foundry Company, which was formed following a devastating fire at the Globe, became a leading manufacturer of bells. Among the most noteworthy industries in Northville was the Northville Valve Plant, transformed by automotive pioneer Henry Ford in 1919 as one of his village industries. The plant, with its trademark waterwheel, produced more than 181 million valves—beginning with those for Model Ts—between 1920 and 1936. Retooled in 1936 to produce intake and exhaust valves, the plant remained operational until 1981. Today the Albert Kahn–designed building has been refurbished and houses a number of offices, including the Detroit headquarters for HKS Architects.

In addition to industrial growth, the aftermath of the Civil War also brought a change to Northville's organizational status. Formerly a part of Plymouth Township, Northville and Plymouth incorporated as separate villages in 1867. Northville would remain a village until 1955, when it was incorporated as a city.

The city's character is due in large measure to the generations of residents and stakeholders committed to creating and maintaining this 2.2-square-mile, picturesque oasis. City street names

reveal not only the contributions of early founders such as Joseph Yerkes, William Dunlap, and Daniel Cady, but others who left an indelible imprint on the community, such as manufacturing and lumber company owner J. A. Dubuar, hotel operator Asa Randolph, and Globe Manufacturing Company founder Francis R. Beal. There are Northville residents today who are descendents of those early pioneers.

The 20th century heralded a new era in transportation for Northville. While the Northville Valve Plant was cranking out valves for the Model T, world-renowned pilot Eddie Stinson began producing the first of his Stinson Aircraft Corporation planes in 1927 in the former Stimpson Scale & Manufacturing Company plant. The company continued to build cabin planes in Northville until 1929, when it moved its operation to Wayne. In 1899, before the manufacturing of automobiles and planes, Northville residents were taking the electric streetcar—or interurban—to destinations as far as Kalamazoo and Grand Rapids. With inexpensive fares—10¢ from Plymouth to Northville—the interurban was a popular form of transportation until its demise in the 1920s. The advent of motorized and electric transport resulted in the gradual demise of the horse-and-buggy.

Though nudged off the road, horses would eventually find a new home on Northville's racetrack. Northville Downs' humble beginnings in the early part of the century at what was then the Northville-Wayne County Fair belied the phenomenon it would become in 1944, when the first nighttime harness racing commenced. A venue for a 1939 exhibition by boxing great Joe Louis, the former fairgrounds is still drawing harness racing fans.

The rise in Northville's manufacturing, industrial, and commercial base resulted in an influx of new housing and neighborhood development. Many of the elegant Victorians that grace Northville's tree-lined residential areas have been painstakingly restored to conform to the city's Historic District Commission standards.

In 1972, Ford Motor Company gifted 12 acres of land on the site of a former gristmill to the City of Northville for the creation of a historical village and park. This resulted in the establishment of the Mill Race Historical Village, a collection of 19th-century structures including a schoolhouse, church, blacksmith, interurban station, Greek Revival and Victorian homes, and an inn once used as a stagecoach stop. All are structures that have their roots in Northville's past. The Northville Historical Society maintains the village.

As the 1970s drew to a close, the city of Northville became one of the first communities in the state to utilize tax increment financing and establish a Downtown Development Authority (DDA) under Michigan Public Act 197. The authority was organized to provide the city with the tools needed to redevelop its downtown in the face of an economic recession. Main Street 78 became the Northville DDA's first major project. The issuance of $1.6 million in bonds allowed for streetscape improvements, including new sidewalks, tree lighting, benches, parking, and landscaping. The redevelopment spurred private investment, resulting in facade and structural improvements to historic downtown buildings that brought increased commerce and served as a catalyst for an implosion of residential development in Northville Township.

The city of Northville often is described as the real-life Bedford Falls, the fictitious town in Frank Capra's iconic film *It's A Wonderful Life*. The small-town charm, quaint downtown, and elegant Victorian structures make it feel like a step back in time. The photographs in this book showcase the city of Northville's history spanning three centuries.

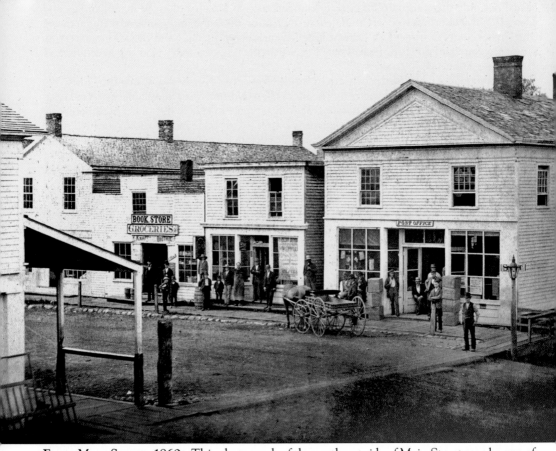

EARLY MAIN STREET, 1860s. This photograph of the southeast side of Main Street may be one of the earliest images of Northville's downtown. Most of the buildings at that time were one-story frame structures. Boardwalks pitched downward to cobbled drainage ditches. Northville's post office is on the right. It would later be relocated to a building on North Center Street before a permanent move to a new structure on South Wing Street, where it is today. Despite Northville's relative seclusion, there was considerable commerce in the village. Among the businesses pictured here are William H. Ambler Stationery, Books, and Jewelry (third from left, next to the post office) and Knapp and Brother, a grocery and general store (second from left). (Courtesy of Richard Ambler.)

One

A TREACHEROUS TREK

Rich farmland and the desire to blaze a trail West drew many Easterners to the Michigan territory in the first quarter of the 19th century. Many of Northville's early settlers came primarily from four counties in upstate New York, including Wayne, Seneca, Ontario, and Livingston. Some traveled from New York by steamship across Lake Erie and then up the Detroit River, while others traveled by wagon through Canada and then by ferry across the river to Detroit. It is estimated that in 1827, some 800 settlers, 200 yoke of oxen, and 20 teams of horses traveled through Canada to Michigan each month.

In May 1831, several families from Ovid in Seneca County, New York, began their trek West. Among those in the party were Capt. William Dunlap; his wife, Sarah; and their four children. In addition, the Dunlaps brought Lewis McCormick, 18, and David Clarkson, 14, to help clear the land. They traveled to Buffalo on the Erie Canal aboard the canal boat *Shark* and then across Lake Erie on the steamboat *New York* before arriving in Detroit. Clarkson described the journey to Northville in his pioneer sketches published in *The Northville Record* from 1874 to 1878. "The streets in Detroit were one continual mud hole, and the roads through the country were worse if possible." The trek from Detroit to the edge of Plymouth Township (which would become Northville) was through heavily wooded, muddy marsh. It would take three days to travel the approximately 30 miles.

Sarah Ann Cochrane, for whom the Northville-Plymouth chapter of the Daughters of the American Revolution is named, shared similar experiences in her family's journey from Detroit to Vermontville Colony near Lansing. Her family would move to Northville in 1842.

"For days we walked more miles than we rode, my mother carrying me on her hip with one arm while with a long pole in the other hand she tested the depth of the mud before each step. My father was often obliged to lead his team over 'corduroy' roads where the logs floated and rolled in liquid mud."

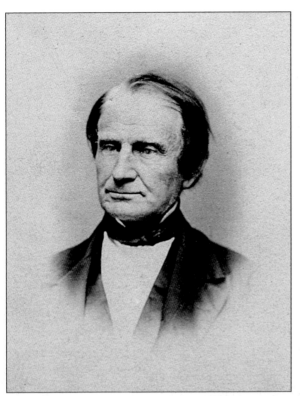

HARVEY AND MARIA BRADLEY.
Harvey Stone Bradley (1797–1881) and his wife, Maria (Rose) Bradley (1799–1896), were among the first settlers filing for land patents in Northville in 1826. The Bradleys moved to the Michigan territory from East Bloomfield, New York. One of their 10 children was Sarah Ann Bradley, who married David Clarkson, another pioneer who arrived in Northville in 1831 with the Capt. William Dunlap party. Harvey was among the organizers of the New School Presbyterian Church in 1845, serving as one of its first trustees. The New Schoolers built a white frame church building on the east side of Wing Street, just south of Main Street. The church served as a library for many years before being moved to Mill Race Historical Village. (Both courtesy of Troy Schmidt.)

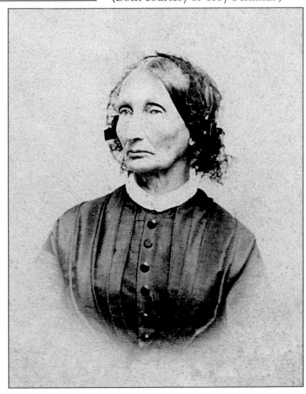

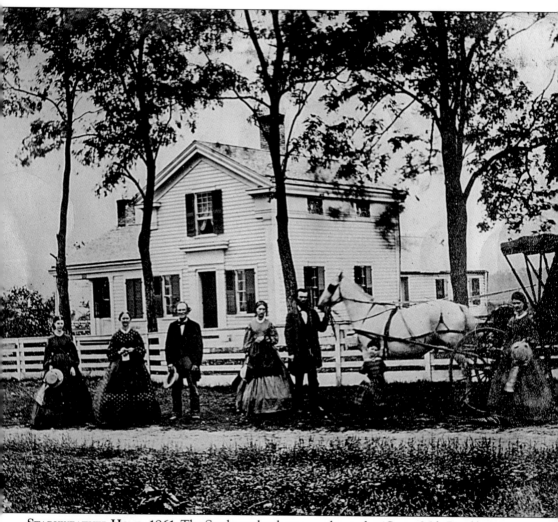

STARKWEATHER HOME, 1861. The Starkweather home was located on Seven Mile Road between Beck and Ridge Roads. The 600-acre horse and cattle farm once stretched nearly a mile, from Seven Mile to Six Mile Roads, and contained more than a half dozen large barns, not including tenant houses and smaller buildings. The Starkweathers were part of the Underground Railroad network that housed runaway slaves fleeing north, many of whom were brought to Northville from Ypsilanti, and then moved on to Detroit. The Starkweathers hid runaway slaves in one of the barns used for quartering sheep. King Starkweather, son of Samuel Starkweather, the farm's original owner, served in the Union Army. Pictured from left to right are Dell Starkweather; Jane Starkweather, wife of Samuel (1819–1912); Samuel Starkweather (1816–1881); Rachel Starkweather, wife of Irving (1841–1916); Irving Starkweather (1838–1912); a horse named Poll; Belle Starkweather; and Ella Thompson.

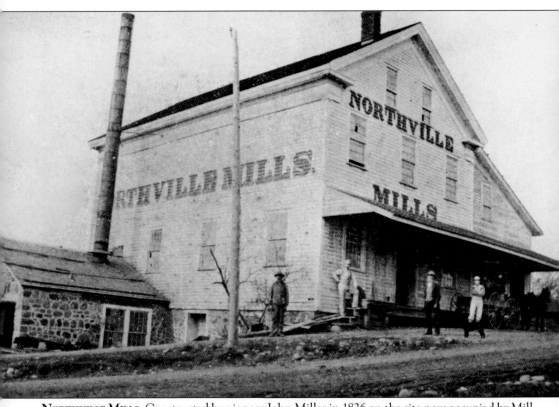

NORTHVILLE MILLS. Constructed by pioneer John Miller in 1826 on the site now occupied by Mill Race Historical Village, Northville's first gristmill was the catalyst for much of the community's growth in its early years. David Clarkson, a chronicler of the village's early years who also worked in the mill, noted that the gristmill was "the beginning of Northville, and John Miller was the pioneer." The mill was among the first in the territory, providing area farmers with a more convenient location for grinding their corn and wheat into flour. At that time, the only other mills were located in Ann Arbor and Pontiac, a considerable distance for early settlers. Capt. William Dunlap purchased the mill and then razed it in 1847 to build a more expansive operation. It was known as the Northville Milling Company or Northville Mills. By the late 1880s, the mill was grinding some 1,000 bushels of grain per day.

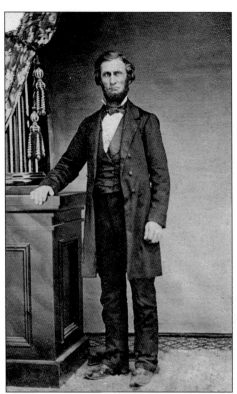

DAVID AND SARAH CLARKSON. Only 14 years old when he traveled to the Michigan territory with Capt. William Dunlap, David Clarkson would become one of Northville's most respected citizens. He left his stepmother and five siblings in 1831 to journey with the Dunlap party. William and Sarah Dunlap adopted David and took him along to raise and to help clear the wilderness. David labored at clearing land, building cabins, hauling goods by ox team to and from Detroit, farming, and grinding grain at John Miller's gristmill. He wrote a series of pioneer sketches for *The Northville Record* from 1874 to 1878. He was a member of the school board and the New School Presbyterian Church. He married Sarah Ann Bradley, the daughter of Northville pioneers Harvey Stone and Maria Rose Bradley, on January 3, 1844. They had seven children, all born in Northville. (Both courtesy of Troy Schmidt.)

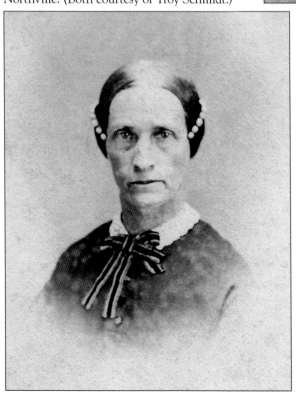

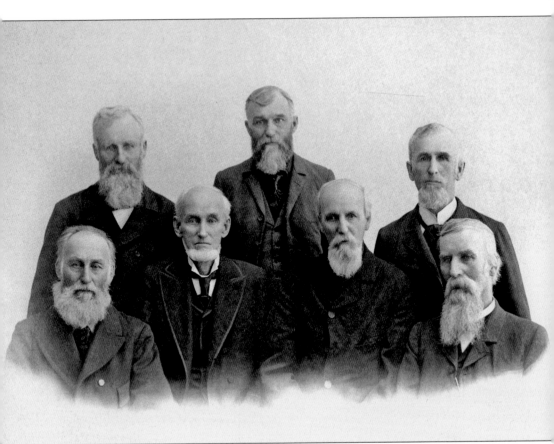

SONS OF WILLIAM YERKES, 1890. William Yerkes was among the earliest settlers to stake his claim in the Northville area in April 1825. He and his wife, Hester, had 10 children, six of whom were born after their arrival in Michigan. The Yerkes would distinguish themselves as one of the community's most prominent families. Their legacy and descendants still remain today. The seven Yerkes brothers from left to right are (first row) Silas, born in 1827 and married to Elanor McCarty; Joseph Dennis, born in 1818 and married to Mary Dunlap; William Purdy, born in 1820 and married to Sarah Cady; Robert, born in 1829 and married to Sarah Holmes; (second row) Charles, born in 1833 and married to Evelina Wells; George, born in 1838 and married to Jane Entrican, and Harrison, born in 1841 and married to Katherine Palmer.

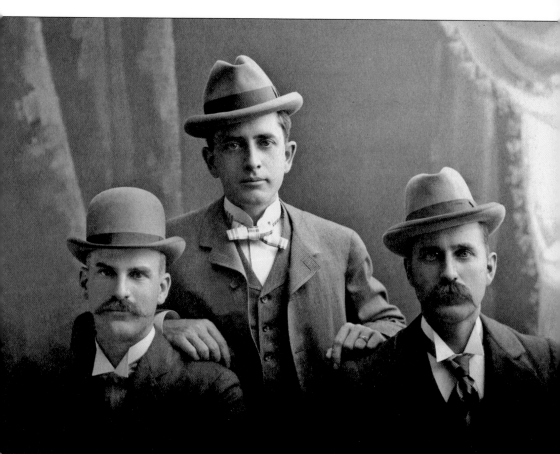

YERKES BROTHERS. This photograph shows three of the grandsons of pioneer William Yerkes. From the left to right are William H. Yerkes, Robert C. Yerkes, and Donald Purdy Yerkes. All three grandsons carried on the Yerkes's legacy and commitment to the Northville community. William served many years as Northville Township Supervisor, and Donald served as president of the Northville School Board. Robert took over the Globe Furniture Company after a devastating fire destroyed the factory in 1899. William and Robert were among the original members of Meadowbrook Country Club when it began in 1916. The Yerkes also purchased Northville Mills in 1890, and it became known as the Yerkes Mill. Automated, new technology would ultimately render the mill obsolete. It was destroyed in 1920.

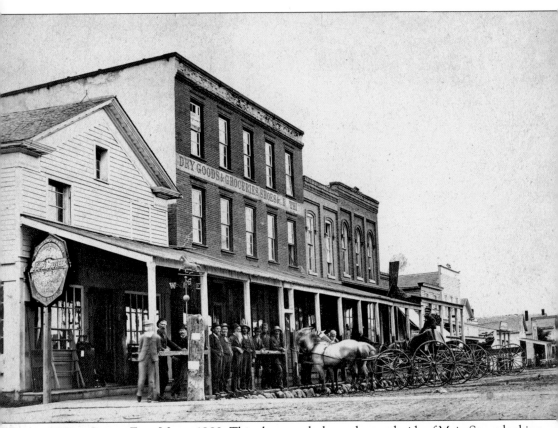

NORTH SIDE OF EAST MAIN, 1882. This photograph shows the north side of Main Street looking east from Center Street. John Miller, owner and operator of Northville's first gristmill, supposedly built the frame structure at the far left in 1830. It was the oldest frame commercial building in Northville and was eventually moved to North Center. It was later destroyed by fire. Pictured left to right are Willie Harrington, Morris S. Nichols, unidentified, Lewis Hutton, unidentified, Capt. ? Van Valkenberg, Ben Lanning, Henry Nichols, three unidentified (the last obstructed by horse), and Hiram Benton. The man in the buggy is unidentified. A boot on the porch roof of the building fourth from the left advertises a boot maker's shop. Northville was a leading manufacturer of custom boots and shoes in the mid-19th century, with more than 40 cobblers engaged in the trade.

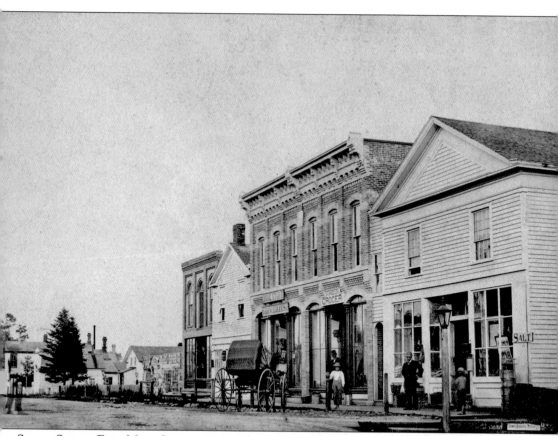

SOUTH SIDE OF EAST MAIN STREET, 1882. This image may have been taken at the same time as the photograph on the facing page. It is possible the photographer documented both sides of Main Street by standing at the intersection of Center Street and focusing east on Main Street. The brick building second from the right was B. A. Wheeler's grocery. In 1880, Barton A. Wheeler began constructing a new store just east of the southeast corner of Main and Center Streets. The brick building replaced a frame structure that can be seen in the photograph on page 10. The Masons persuaded Wheeler to add a second story to the building that it later leased as its new headquarters. At that time, the Masonic Temple Association of Northville was formed to manage and maintain the building. The former Wheeler grocery is today one of the oldest buildings on the south side of downtown Main Street.

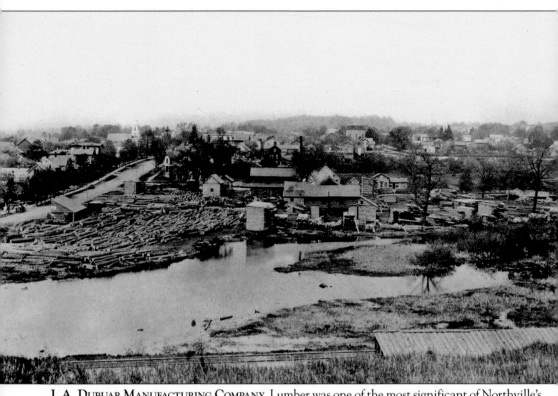

J. A. Dubuar Manufacturing Company. Lumber was one of the most significant of Northville's early industries, and J. A. Dubuar's company was the local leader. This image from 1887 shows the expanse of the operation in the vicinity of Griswold and Main Streets on a site that today houses the former Ford Valve Plant. In addition to the mill, there were numerous lumber sheds and frame buildings used for storing various materials. By the late 1880s, the company had expanded its base of operation, becoming J. A. Dubuar Manufacturing Company and later the Union Manufacturing and Lumber Company, producing a variety of products including pulleys, pulley blocks, wheelbarrows, screen doors, wooden mast hoops, and hose reels. The company eventually began producing air rifles with names such as the Globe, General Custer Repeater, and Michigan, which could be purchased from the Sears, Roebuck and Company catalog for 63¢. The mill was a vital part of the community until the death of James Dubuar in 1919, its principal stockholder, president, and general manager.

Two

GRISTMILL SPURS GROWTH

Gideon P. Benton, who purchased 240 acres of what is today the southeast corner of Six Mile and Northville roads, filed the first land patent issued for Northville in 1823. Within the next decade, other settlers began to stake their claims. The Dunlaps were the principal settlers north of Main Street on both sides of Center Street, with Daniel Cady pioneering the land bounded by East Main Street and Seven Mile and South Center Street to Northville Road. Hiram Robinson claimed property west of South Center Street and south of Main Street.

The town took its name from its location north of Plymouth. In his *Northville Record* sketches, pioneer David Clarkson noted that the "citizens held a meeting in Mead's store to decide on a name for the place and 'Northville' was the name decided upon." The post office was established in Northville in 1831, with Jabish M. Mead serving as the first postmaster.

William Dunlap sold off lots from his farm to develop the first plot of the village in the spring of 1832. He also built the first frame house in Northville in 1832 at the corner of Center and Dunlap Streets (now the American Legion headquarters).

One of the catalysts for development of the village was the construction of John Miller's gristmill around 1827 on the southern edge of what today is Mill Race Historical Village. Miller's gristmill was the first in Plymouth Township and one of the first in the territory, providing farmers in the area with a convenient location to have their wheat and corn ground into flour. The other two mills were located in Ann Arbor and Pontiac, a lengthy trip from Western Wayne County.

The mill put Northville on the map, bringing visitors and settlers alike and helping spur development of the village.

When her minister father left the Vermontville Colony near Lansing in 1842 in search of a new pulpit, pioneer Sarah Ann Cochrane wrote in her reminiscences that when "an opening at Northville presented, it was readily accepted. The village was past the pioneering stage and quite attractive, and the community of excellent repute."

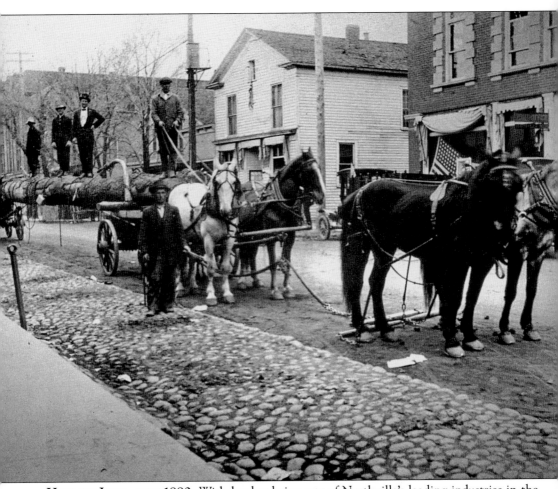

Hauling Logs, post 1880. With lumber being one of Northville's leading industries in the 19th and early 20th centuries, it was not unusual to see teams hauling logs through the streets of downtown. While J. A. Dubuar Manufacturing Company was Northville's principal sawmill, there were others mills in the community that obtained choice Michigan hardwood from local farms. Hardwood lumber also was produced from logs purchased throughout the country and shipped from various points on the Flint and Pere Marquette Railroad. As evidenced in this photograph, hauling logs—or even one log—took considerable man and horse power. This team is headed south on North Center Street toward the intersection at Main Street. In the background at left is the Northville Opera House—later the Moffat Opera House. The building on the right still stands today as Orin Jewelers. Hitching posts visible in the forefront were still evident on downtown streets but would soon outlast their usefulness.

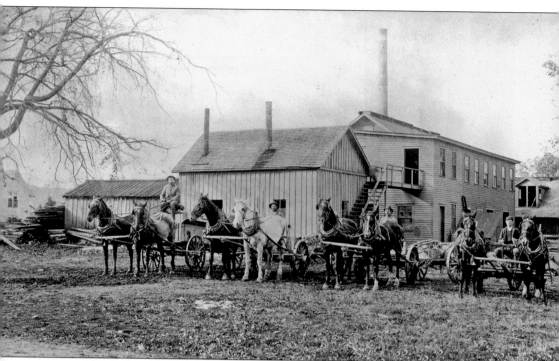

READING THE TEAMS, 1890. The log teams at J. A. Dubuar Manufacturing Company prepare to haul their goods from the site at Griswold and Main Streets. Logs were easily purchased from local farms in the early years of the operation but became more difficult to obtain as manufacturing increased. Equipped with a 5-foot circular saw and a top saw, the Dubuar mill was able to cut logs of a very large diameter. The sawmill produced air or kiln-dried lumber from a variety of species, including maple, black walnut, white elm, red elm, black gum, basswood, white ash, tulip, poplar, beech, red oaks, and white oaks. Many of Northville's early homes, churches, and businesses were constructed from wood cut at the Dubuar mill. The elaborate woodwork of the former Northville Methodist church at Dunlap and Center Streets was purchased from the mill. The mill employed between 40 and 60 workers at any one time during its half-century of business.

BELL CAPITOL. The formation of the American Bell and Foundry Company in 1899 would put Northville on the map as a worldwide leader in bell manufacturing. The photograph, taken prior to 1912, is of foundry workers William Lincoln (left) and Dave Lanning. Located at the east end of Cady Street, the company also contained a machine business and general foundry. It discontinued its bell-making business in 1924. Though American Bell and Foundry was Northville's most successful bell manufacturer, bells and other metal products were produced by the Michigan School Furniture Company, founded in 1873 by Charles Harrington and Francis R. Beal. The company produced school and church furniture as well as metal products.

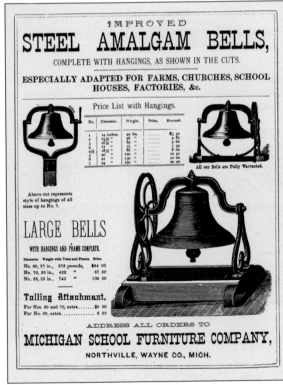

STIMPSON SCALE & MANUFACTURING. The Stimpson Scale & Manufacturing Company, later the Stimpson Scale and Electric Company, was headquartered in Milan but opened a facility in Northville in the 1890s on the site of Ebenezer Pennell's carding mill on what is Cady Street today. It produced scales and coffee mills in Northville for more than 20 years. The only identified construction worker pictured is Fred Perry, second from right.

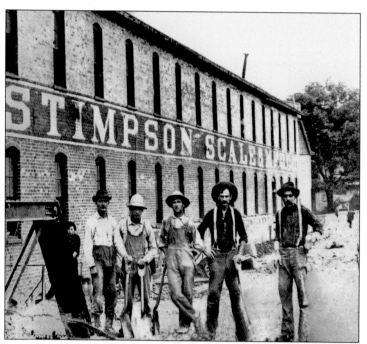

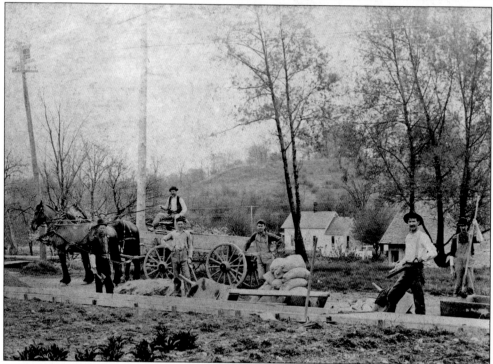

LAYING SIDEWALKS. Construction workers pause while pouring sidewalks for what may have been Northville's earliest concrete walkways. The bags piled near the wagon most likely are filled with cement. Northville's first sidewalks were made of wooden planks. In accordance with an ordinance passed by the village council in 1867, plank walks were to be 2 inches thick and not less than 5 feet wide.

GLOBE FURNITURE COMPANY, 1927. This photograph depicts the once dominant Globe Furniture and Manufacturing Company, rebuilt after a devastating fire in 1899. It began as the Michigan School Furniture Company in 1873, producing school and church furniture in an industrial complex on Cady Street. It soon became the largest manufacturer of school furniture in the world. By 1887, the name was changed to the Globe Furniture Company.

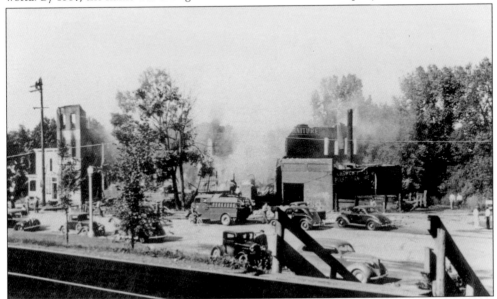

GLOBE FIRE, 1930s. Once reduced to ashes in a devastating fire in 1899, the Globe Furniture Company, at one time the worldwide leader of manufactured school furniture, was rebuilt on the same site. Despite efforts to restore the company to its former greatness, the Globe never recovered. On November 19, 1931, the Globe closed. Years later, in an ironic twist of fate, the abandoned Globe factory burned to the ground.

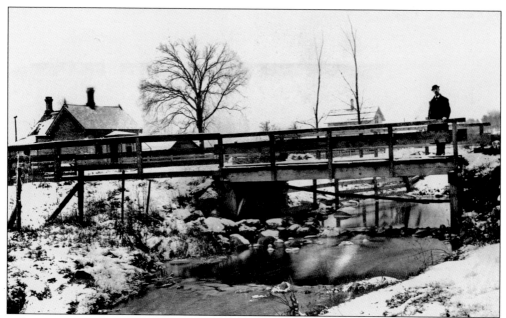

PARMENTER'S, 1880s. Civil War veteran Benijah Aldrich Parmenter used his service pension to build a cider mill on Base Line Road. An unidentified man is pictured standing on the Novi Road bridge at Base Line Road. The mill can be seen in the background next to the house on the left. Charles Schoultz, a World War I veteran who helped organize the Northville American Legion Post 4012, once owned the house.

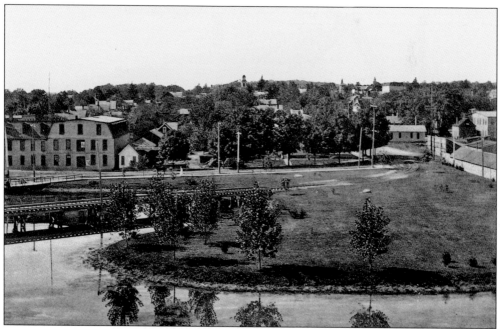

VIEW FROM THE TRACKS, 1908. The village of Northville, looking west from the railroad tracks, can be seen in the background. The Union Manufacturing and Lumber Company, formerly J. A. Dubuar Manufacturing, is to the far right, with the interurban tracks visible in the foreground. Church steeples can be seen over the tops of trees.

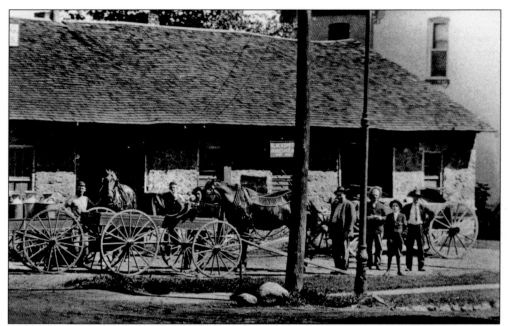

HIRSCH BLACKSMITH SHOP, 1913. John Hirsch's Blacksmith Shop was a mainstay for shoeing horses for nearly 50 years. Hirsch came to Northville from New York in 1865 and established his shop on the northeast corner of Wheelbarrow Avenue (later changed to Atwater and now called Hutton) and Main Street. The building was demolished in 1930. A reproduction of the blacksmith shop was constructed in 1983 at Mill Race Historical Village.

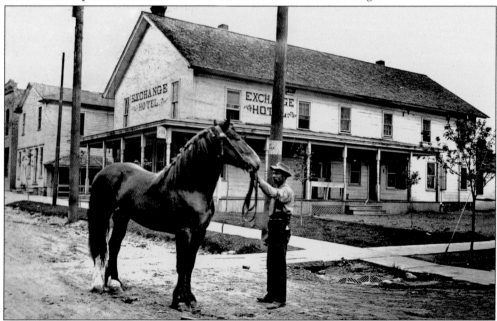

EXCHANGE HOTEL, C. 1880. Located at the northwest corner of Main Street and Hutton Avenue (then Atwater), the hotel was owned by George Stanley, who also operated the Stanley House, west of the Exchange Hotel. Northville was the site of numerous hotels, taverns, and inns throughout the 19th and early 20th centuries.

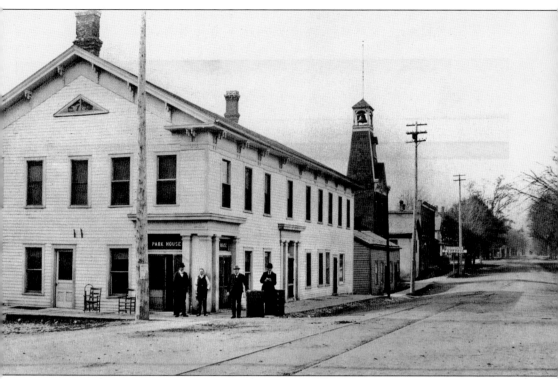

PARK HOUSE, 1889. Located on the southwest corner of Main and Center Streets, the Park House was the leading hotel in town, noted for its well-stocked bar and excellent cuisine. It was touted as "the best $2 per day house in Michigan." The building was originally the Ambler House, built in 1858 by William Ambler. An abolitionist, Ambler and his wife, Ursula (Randall) Ambler, moved to Northville in 1854. The hotel was the first balloon frame building in the area. It was also the headquarters for the stage routes to Detroit and a popular stagecoach stop for weary travelers. By 1889, the hotel had been purchased by O. Butler and Sons, which completely remodeled and refurnished it. In 1893, the hotel was put on the market again and was purchased by William Thurtle, a retired lumberman who also purchased the Northville Opera House. In 1929, it was totally destroyed by fire.

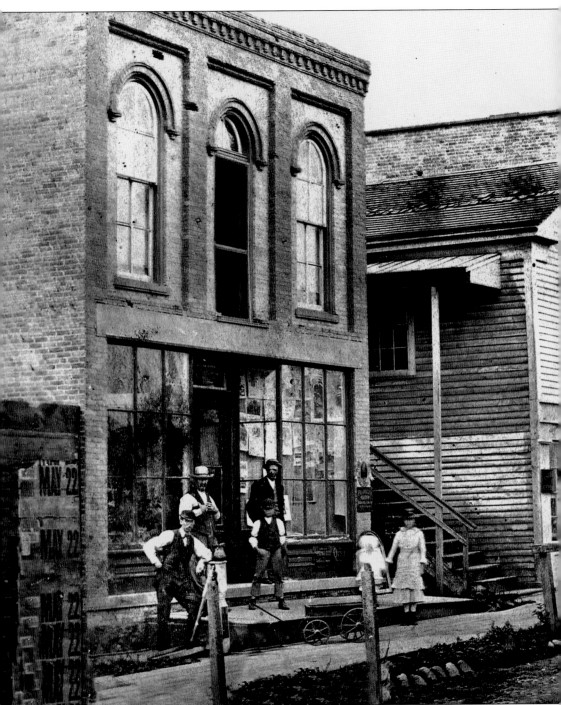

EAST MAIN STREET, C. 1880s. This image shows the south side of East Main Street looking west toward Center Street. It offers a different perspective of the street featured on page 19. The frame building housed between the two brick structures is a millinery and dry goods store. Dominating the block is the two-story brick B. A. Wheeler building, third from left, which housed a grocery. The Masonic Lodge occupied the upper level of the building. Wheeler's building eventually was

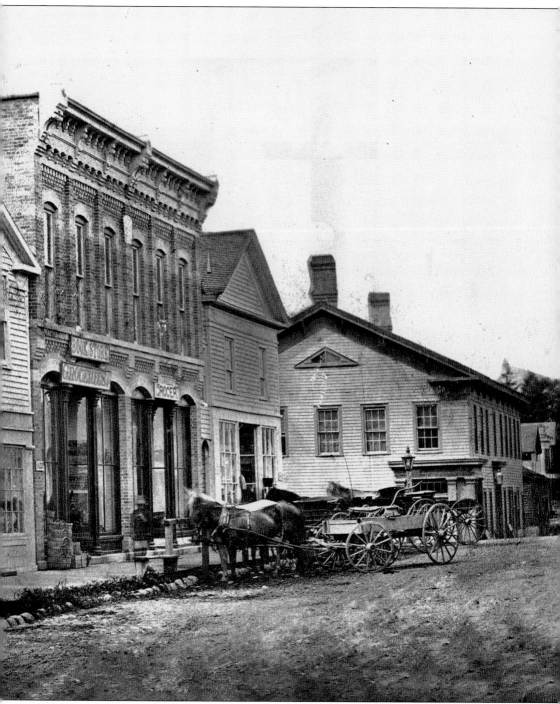

expanded to the corner of Center and Main Streets, replacing the frame structure, fourth from left. Wheeler retired in 1917 after 43 years in the grocery business. He died in 1932. Genitti's now occupies the former B. A. Wheeler building. In the background, located across Center Street, is the Ambler House hotel, which eventually became the Park House. (Courtesy of Richard Ambler.)

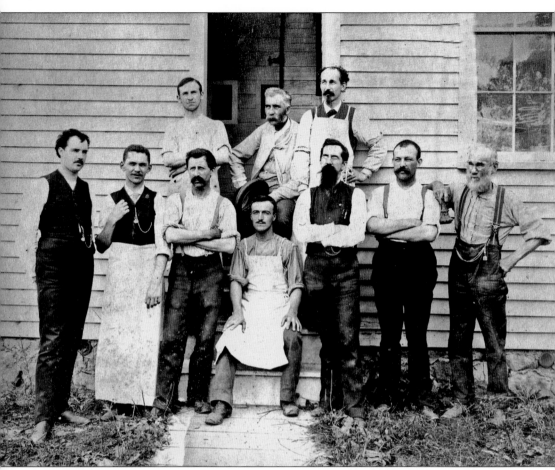

GRANVILLE WOOD AND SON, 1884–1889. The Granville Wood and Son pipe organ factory was organized in 1884 with Granville Wood as superintendent. The factory was located next door to the Globe Furniture Company. Organs manufactured there were sold for up to $5,000. Later, pianos were also produced. In 1889, the company was sold to Farrand, Votey, and Company and was moved to Detroit. Pictured from left to right are (first row) William Wood, son of Granville Wood; unidentified; Frank Shafer; unidentified; ? Wade of Detroit; unidentified; and Frank Macomber, whose wife ran a boardinghouse on Main Street and whose son William operated the Peerless Steam Laundry; (second row) unidentified; Granville Wood, owner of the factory; and Anthony H. Kohler. Due to poor health, Kohler was forced to give up factory work. He later opened a grocery store across from the train depot.

Three

COBBLERS, COOPERS, AND CARRIAGE MAKERS

Northville's growing prosperity occurred against a backdrop of national strife. Of the approximately 150 Northville men who served in the Civil War—in battles ranging from Bull Run and Gettysburg to the Wilderness and Chickamauga—more than a third would not return home. Those who did would find an increasingly thriving community and growing opportunity.

Among the returning veterans who parlayed their war pensions into business ventures was Benijah Aldrich Parmenter, who enlisted in the U.S. Navy in 1862 aboard the *U.S.S. Elfin*. After the ship was destroyed, he served on the *Cincinnati* until the end of the war. In 1873, he used his military pension to purchase a mill on East Baseline for making cider, apple butter, and vinegar. Parmenter's Cider Mill remains to this day one of the oldest continuing businesses in Northville.

As Northville's population grew, so too did its downtown. Its secluded location necessitated the manufacturing and industry that supported the self-sustaining community. Lumber became a booming industry, with James A. Dubuar's sawmill flourishing. Main and Center Streets were lined with framed, predominantly clapboard structures boasting general stores, liveries, millineries, carriage makers, coopers, and taverns.

Northville was a destination for those seeking handmade boots and shoes. Nearly 40 cobblers were employed in the shoe and boot making business, tossing so many leather scraps in the street that years later a 6-to-8-inch layer of leather, 100 feet in diameter, covered an area of Main Street.

Northville built its first schoolhouse in 1833 and saw its first high school graduate, Alice Beal, receive her diploma in 1868 from Northville Union School, the community's first high school.

On March 13, 1867, with a population of approximately 700, Northville incorporated as a village.

Another milestone for Northville came on July 15, 1869, when Samuel Harkins Little, a 23-year-old store clerk, published the first four-page edition of *The Wayne County Record*, Northville's first newspaper. Pressed at the *Detroit Free Press* office with cheap handset type, the first edition was the beginning of what would become *The Northville Record*, the oldest continuously published weekly newspaper in Wayne County.

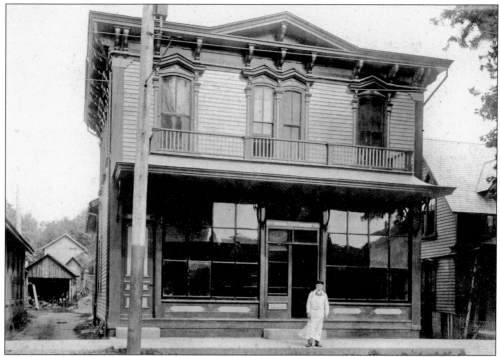

HILLS BUTCHER SHOP. Built in 1870 by Charles Waterman, the building was purchased in 1881 by Frank Miller, uncle of Frank and George Hill. It was the F. A. Miller Meat Market before the Hills' brothers took over the operation. The building, located on West Main Street between Center and Wing Streets, was razed in 1959 to make way for a municipal parking lot.

THE BEAN SHOP, 1910. Ina Ware's restaurant was called The Bean Shop, and she was often referred to as Mrs. Bean. The restaurant was located at 141 East Main Street. Tom Ware, Ina's husband, is pictured at the counter of the restaurant. Ware was a mason who built many of the brick buildings in Northville and Plymouth. His name can still be seen on buildings throughout the downtown.

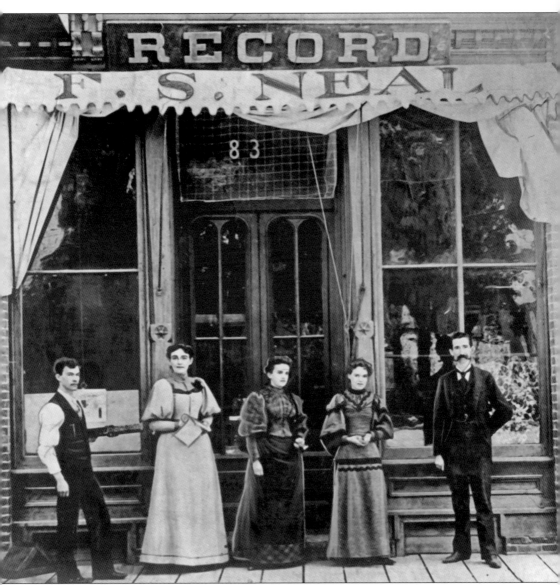

THE NORTHVILLE RECORD. Frank S. Neal purchased *The Northville Record* in 1891 from A. C. Waterhouse. He published the paper for 28 years—one of the longest ownership tenures in *The Record's* storied history. He sold it in 1919 to E. E. Brown. Neal is seen at right with employees in front of *The Record* office in the opera house building on the east side of North Center Street. It is believed *The Record's* first downtown office was located on the northeast corner of Main and Center Streets on the second floor of what was likely the first frame commercial building constructed in Northville. The first edition of *The Northville Record* was published on July 15, 1869, under original owner Samuel H. Little as *The Wayne County Record*. On December 24, 1870, Little changed the name of the paper to *The Northville Record*. It remains the oldest continuously published weekly newspaper in Wayne County.

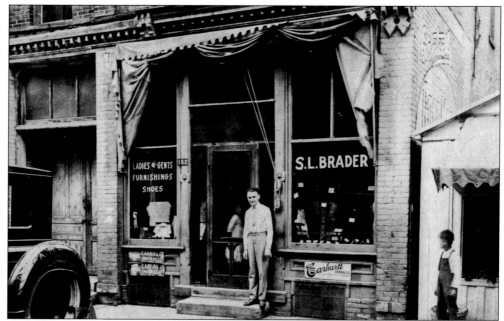

S. L. Brader, 1924. Sam and Mary Brader first opened Brader's Department Store in 1924 in the lower level of the Northville Opera House. The store was located in space formerly occupied by *The Northville Record*. In 1928, Brader's relocated to a newly constructed building at 141 East Main Street. Sam Brader's nephew, Harry Himmelsteib, joined his uncle in operating the store until illness forced Brader to sell out in 1945.

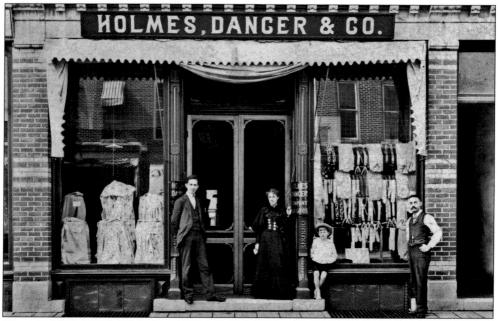

Holmes, Dancer, & Company, 1890s. Located at 120 East Main Street, the dry goods store carried a variety of items for both women and men, including suspenders that appear in ample supply in the display window at right. Holmes, Dancer, & Company was among the first downtown businesses to subscribe to the then new telephone service in 1897.

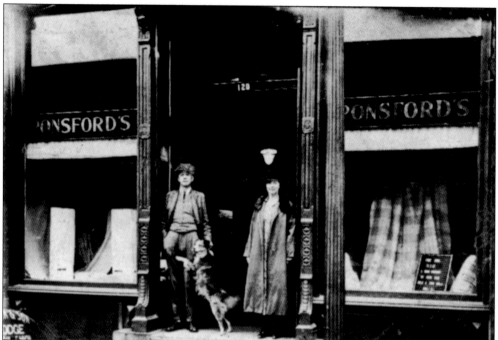

C. A. PONSFORD. Charles A. Ponsford opened his dry goods and notions business in 1910 at the former Holmes, Dancer, & Company location at 120 East Main Street. At the time Ponsford purchased the dry goods store, it was owned by T. J. Perkins. Ponsford was one of Northville's most prominent citizens, serving on the Northville Board of Education, the Northville-Wayne County Fair association, and the board of directors of Lapham Savings and Loan. He died in 1932. His grandson Charles Ponsford Lapham eventually took over the family business in the same location. Pictured is C. A. Ponsford with store clerk Elizabeth Cobb in front of the store in 1920. An advertising supplement celebrates Ponsford's fifth anniversary in business in 1915. Staple articles of dry goods always available included corsets, gloves, silk hosiery, waists, and silks. (Both courtesy of Charles P. Lapham.)

APRIL, 1910 ———— APRIL, 1915.

Our Fifth Anniversary

SATURDAY APRIL 24 TO SATURDAY, MAY 1--INCLUSIVE.

FIVE YEARS AGO we opened our doors to do a Dry Goods business in Northville. After five years we think that every resident of this community knows of our store and of our method of doing business.

That portion of patronage that you have extended to us is greatly appreciated and we take this occasion to thank you for it. We feel that we merit your trade and confidence purely from the system we have applied to our business building.

STRAIGHT LINE MERCHANDISING

Demanding from those who would supply us the very best lines of merchandise and in turn selling the same over our counters at the very lowest "live and let live" rate of profit.

This principal, combined with efficient **Store Service,** we find works out satisfactorily and on this combination we are willing to bank our future.

Just to celebrate these five years (or twenty seasons), of business we are going to offer 20 Specials (one for each season) especially priced for this week only. Each and every item is a Real Bargain, which we are sure you will want to take advantage of.

CHARLES A. PONSFORD
DRY GOODS AND NOTIONS. **NORTHVILLE, MICHIGAN.**

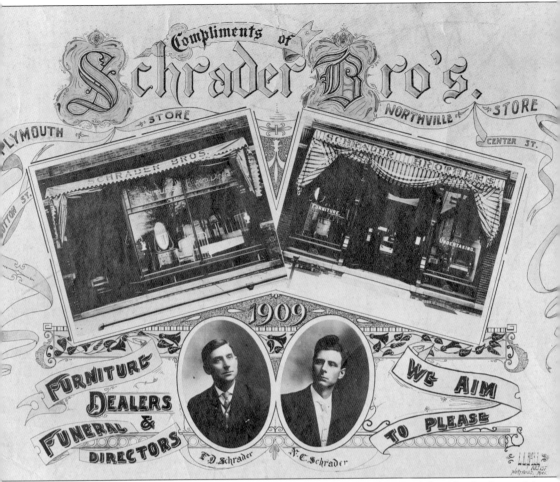

SCHRADER BROTHERS, 1909. Nelson C. Schrader Sr. and his brother, Fred, bought the former M. A. Porter Furniture and Undertaking business at 111 North Center Street in 1907. The brothers owned a similar business in nearby Plymouth. In 1925, the brothers dissolved the partnership, and six years later, Schraders of Plymouth discontinued its furniture line. Nelson continued to operate the Northville store. He was a leading citizen of the community, serving as was one of the original incorporators and members of Meadowbrook Country Club and serving on the inquest jury of the 1907 Pere Marquette Railroad collision in Northville Township, Michigan's worst passenger train accident. Nelson Schrader's son took over the business upon his father's death in 1936, and it later was passed on to the founder's grandson. The 1909 calendar cover showcases the Schrader Brothers' two store locations.

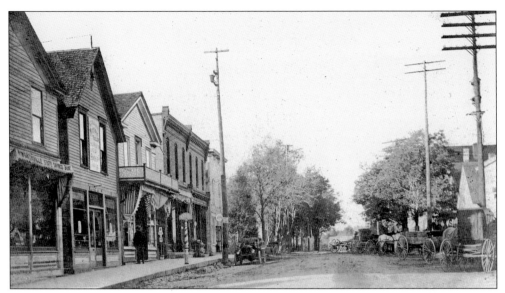

NORTH CENTER STREET, PRE-1907. This picture of the west side of North Center Street shows the contrast of buildings and transportation. Buildings from left to right are the Northville State Savings Bank, the post office, Scott and Jackson's drugstore, and the 1888 brick building that housed the M. A. Porter Furniture and Undertaking business. The automobile parked in front of that building may be owner M. A. Porter's Maxwell.

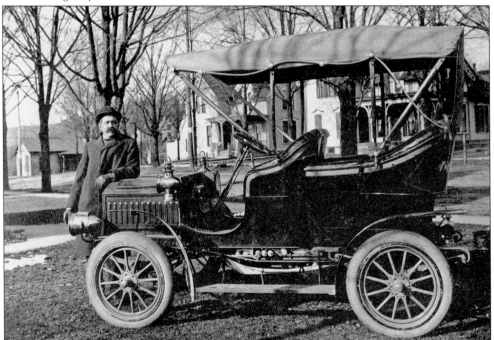

M. A. PORTER AND HIS MAXWELL. Marion A. Porter poses with his Maxwell. Porter was a partner in Sands and Porter furniture and funeral parlor (later M. A. Porter Furniture and Undertaking) on North Center Street and also operated the first telephone company in the village. Porter came to Northville in 1882 and married Belle Sands. He housed his Maxell in the barn behind his home at 537 Dunlap Street.

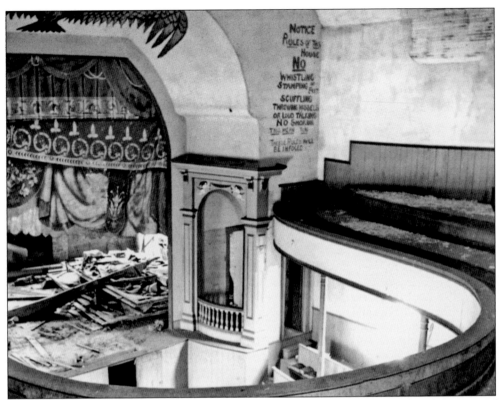

OPERA HOUSE CURTAIN CLOSES. The Northville Opera House was the brainchild and obsession of *Northville Record* founder Samuel H. Little. Determined to bring an opera house to the community, Little began his quest in 1876, seeking donations from business owners and residents. He raised money on his own by taking odd jobs outside of his newspaper duties. He gave *Record* readers regular construction updates and pleaded for donations. Progress on the building was slow, and Little's commitment to his publishing duties waned. The opera house was completed in 1879, but it is not known whether Little ever witnessed its grand opening. The December 13, 1879, issue of *The Northville Record* was the last to carry Little's title as editor. These images show the balcony interiors of the four-story, 800-seat building after its closure.

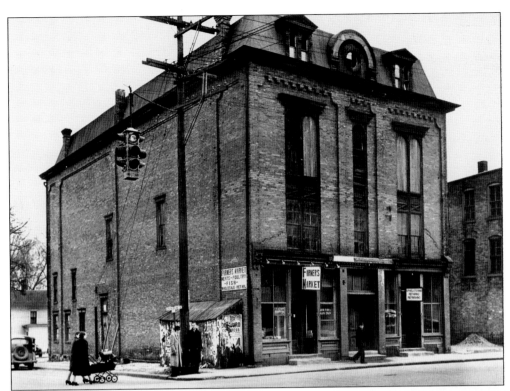

NORTHVILLE OPERA HOUSE. This image shows the Northville Opera House, long past its prime. The offices were leased to a farmer's market, Twin Pines Dairy Shop, and an upholstery business. Henry Ford I wanted to save the building and restore it in Greenfield Village in Dearborn. The owner, Sam Pickard, chose to demolish the building rather than sell it for less than asking price. It was razed in 1950.

OPERA HOUSE PROGRAM, 1889. The Northville Opera House was the venue for a variety of musical and theatrical performances, including local productions. The 800-seat facility was used for the high school's commencement ceremonies, community band performances, and local musical groups. The June 14, 1889, program showcases the cantata *The Flower Queen*, featuring many local residents, including Anna Clarkson, Flora Babbitt, Lydia Starkweather, Grace Yerkes, and others.

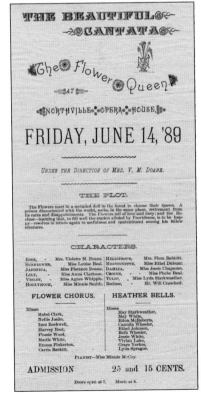

ROGERS AND MAIN STREETS. The Ambler home on the corner of Rogers and Main Streets was a stately brick Victorian built in 1888. This photograph, taken in 1910, shows the canopy of trees that covered West Main Street's residential neighborhood. The image is looking east from the corner.

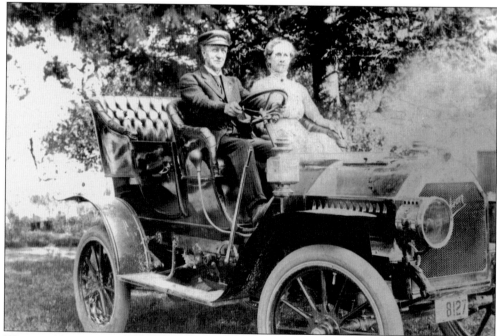

WILLIAM AMBLER AND HIS JACKSON. William Ambler and his wife, Sarah, pose in his 1908 Jackson at their home on the corner of Rogers and Main Streets. The Amblers owned one of the first automobiles in Northville. William Ambler was an insurance and real estate agent and one of Northville's leading citizens. He served on the inquest jury of the 1907 Pere Marquette Railroad collision. (Courtesy of Richard Ambler.)

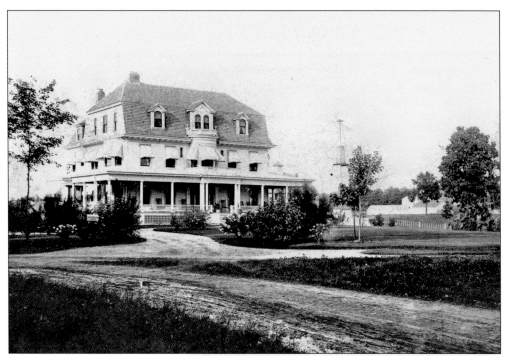

EATHERLY ESTATE. Florance D. Eatherly built this mansion on his 110-acre estate at Griswold and Base Line, where the late William Chase's home stands today. Eatherly made his fortune in the lumbering business and was president of the Union National Bank of Detroit. He served as police commissioner under Detroit mayor Hazen S. Pingree, who was later elected governor of Michigan (1897–1900). The mansion, called Braeside, cost about $10,000 to construct in 1899. Eatherly is pictured on the front porch of his home. He died in 1916 at age 82. George Yerkes eventually purchased the estate. A fire destroyed the home in 1922.

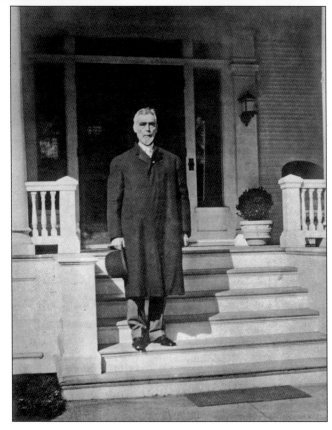

NORTHVILLE ILLUSTRATED, 1892. The Eagle Steam Printing and Engraving Company published *Northville-The Ideal Suburban Village* in 1892 to promote the virtues and growing popularity of the Village of Northville. The book highlighted the community's extensive manufacturing, its vital downtown, and its diverse retail segment, as well as other noteworthy institutions. The Eagle Steam Printing and Engraving Company was established in 1869 and specialized in first class engraving and printing, including fine cut and catalog work and artistic designing for programs, invitations, and letterheads. It was located in a frame building on East Main Street that once housed *The Northville Record* just prior to 1892, when publisher Frank Neal moved the newspaper operation to the Northville Opera House. By 1893, the Eagle building had become the headquarters for the women's temperance organization.

Four

THE IDEAL SUBURBAN VILLAGE

In 1892, the Eagle Steam Printing and Engraving Company published a book titled *Northville-The Ideal Suburban Village*. The handsome, little book contains illustrated engravings of the community's landmarks, manufacturing firms, and downtown businesses with accompanying text extolling the virtues of each. Though likely designed as a marketing vehicle, it nevertheless illustrates the prosperity of the village of Northville at the close of the century.

According to the U.S. Census records, the population of Northville in 1890 was 1,573. Three years later, its population had grown to 1,721. Many of the village's stately Victorian homes were built in the last two decades of the 19th century.

By the 1890s, Northville's manufacturing was at its peak. According to *Northville-The Ideal Suburban Village*, Northville ranked second only behind Detroit in manufacturing in Wayne County.

Among the most noted industries were the Globe Furniture Company, which employed 200 workers and manufactured more church and school furniture than any other establishment in the world; Clover Condensed Milk, which had its beginnings in the 1830s when Charles Rogers invented the milk condensing machine; J. A. Dubuar Manufacturing Company, which expanded from its sawmill roots into the manufacturing of other items such as wheelbarrows, screen doors, and rifles; and Northville Mills, now under the ownership of brothers William and Robert Yerkes.

In addition to manufacturing, the village's downtown continued to flourish. Merchants included: Frank N. Perrin, who provided the county with carriages, wagons, and horseshoeing; Teichner and Company, offering an emporium of dry goods, furnishings, and groceries; and the F. A. Miller Meat Market.

Northville's first railroad station opened in 1871 to much fanfare. The Park House (formerly the Ambler House) at the southwest corner of Main and Center Streets provided weary travelers excellent accommodations, fine cuisine, and a well-stocked bar. For those who imbibed too much, the Yarnall Gold Cure Institute on Main Street offered treatment for "liquor-cursed men."

Jared S. Lapham opened the J. S. Lapham and Company Bank in 1869 and put his daughter, Mary Lapham, in charge as cashier. Mary, an astute businesswoman, would become the bulwark behind the formation of Northville's first library.

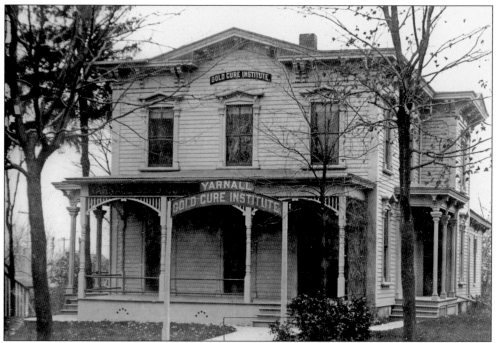

Yarnall Gold Cure. The Yarnall Gold Cure Institute opened its doors at 404 West Main Street in 1892 for the treatment of alcoholism and other addictions. Its founder, Dr. William H. Yarnall, considered it "an institution for the rational treatment and radical cure of the alcohol, opium, cocaine, tobacco, and cigarette habits." In 1892, three weeks of treatment for alcoholism cost $50, "payable in advance."

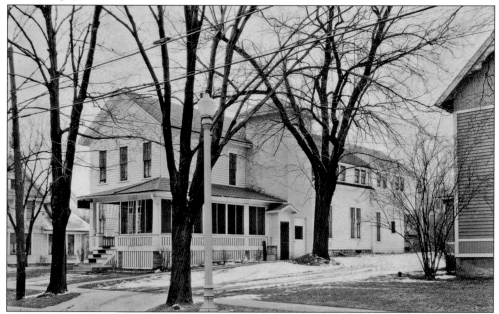

Sessions Hospital. Sessions Hospital, the first hospital in Northville, opened in 1879 at 520 West Main Street. This photograph was taken on May 19, 1937. Sessions Hospital later became the Northville Community Hospital and today is Star Manor Nursing Home.

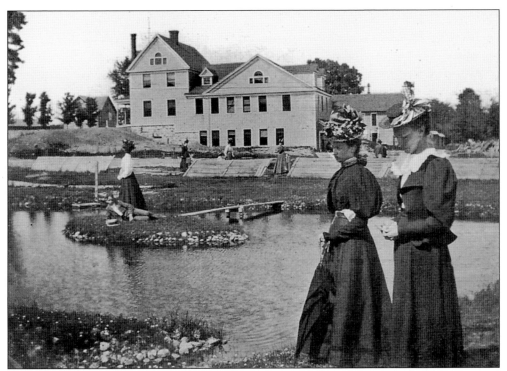

NORTHVILLE FISH HATCHERY, 1897. This image shows visitors taking a leisurely stroll around the 17-acre fish hatchery ponds that dominated both sides of Fairbrook Street for more than 50 years. The operation, which would eventually become one of the finest hatcheries in the country and the first federal fish hatchery in the nation, was started in 1874 by prominent fish breeder Nelson Clark of Clarkston. (Courtesy of Troy Schmidt.)

SUPERINTENDENT'S COTTAGE. Though the driver of this buggy is unidentified, the house in the background was the residence of the fish hatchery superintendent. Among the 17-acre fish hatchery site were several buildings on both sides of Fairbrook, west of Rogers Street, that served as housing and offices for hatchery employees. The superintendent's cottage, now a private residence, is the only hatchery building remaining today.

FISH HATCHERY PONDS. More than 5 acres of the 17-acre fish hatchery property were under water. Two main springs produced about 375 gallons of water per minute. Millions of game fish were reared at the fish hatchery and shipped throughout the world. In the 1890s, it contained some 250,000 trout of different species and about 10,000 stockfish.

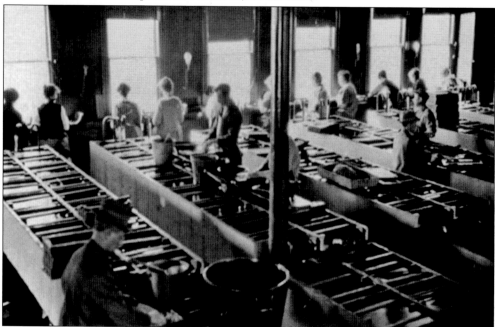

FISH HATCHERY OPERATION. Upon the death of fish hatchery founder Nelson Clark in 1876, only two years after opening the Northville operation, Frank Clark took control of his father's business. Under Frank's management, the hatchery grew to become a national leader. Workers in this photograph check thousands of eggs inside one of the hatchery laboratories.

SUPERINTENDENT WILLIAM W. THAYER. Frank Clark, son of fish hatchery founder Nelson Clark, elevated the fledging Northville hatchery to national prominence. In 1880, the U.S. government bought the buildings and made Frank superintendent of the nation's first U.S. Fish Hatchery. Upon Clark's death in 1910, William W. Thayer, one of the community's most prominent residents, took over as superintendent. He would serve in that capacity for 20 years. Thayer's superintendent's license from 1918 was issued by the U.S. Department of Commerce. Thayer died in 1930. The U.S. Fish Hatchery in Northville was the only federal fish hatchery still in existence in Michigan in 1935. By the late 1930s, the operation was closed and its buildings razed.

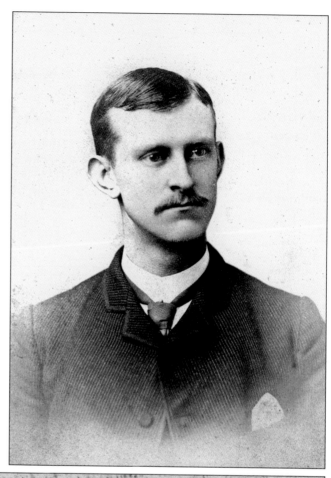

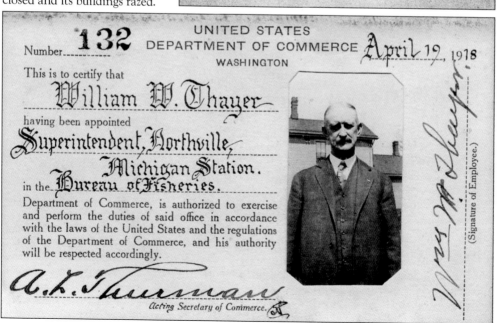

Number 132

UNITED STATES DEPARTMENT OF COMMERCE
WASHINGTON

April 19, 1918

This is to certify that

William W. Thayer

having been appointed

Superintendent, Northville,
Michigan Station.

in the Bureau of Fisheries.

Department of Commerce, is authorized to exercise and perform the duties of said office in accordance with the laws of the United States and the regulations of the Department of Commerce, and his authority will be respected accordingly.

A. L. Thurman

Acting Secretary of Commerce.

(Signature of Employee.)

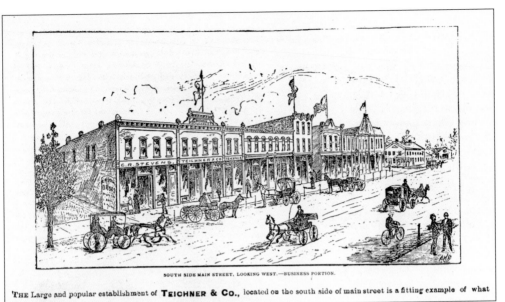

SOUTH SIDE MAIN STREET, LOOKING WEST.—BUSINESS PORTION.

THE Large and popular establishment of **TEICHNER & CO.,** located on the south side of main street is a fitting example of what

TEICHNER & COMPANY, 1892. Teichner & Company, one of Northville's many dry goods stores, received prominent display in the Eagle Steam Printing and Engraving Company book, *Northville-The Ideal Suburban Village.* The store was located on the south side of East Main Street. The engraving also illustrates the brick buildings lining the Main Street block, replacing the earlier framed one-story structures.

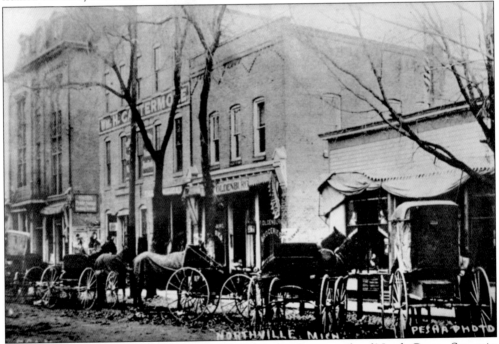

NORTH CENTER STREET, 1911. Buggies are lined up on the east side of North Center Street in this 1911 street scene. The Oldenburg building (second from right) and the Wm. H. Cattermole building (third from right) are still standing today. The Northville Opera House, next to the Cattermole building, was razed in 1950.

CHARLES EUGENE CLARKSON. The first of eight children of Northville pioneer David Clarkson and his wife, Sarah, Charles Eugene Clarkson was born in 1844. In 1861, he enlisted in Company G of the 14th Michigan Infantry Volunteers. He was honorably discharged as a sergeant in 1865. He eventually opened a painting and "paper hanging" business on Main Street. He married Eveline Nash in 1872. (Courtesy of Troy Schmidt.)

EAST SIDE OF CENTER. This photograph shows the buildings at the southern end of the east side of North Center Street. The building on the far right was the office of *The Northville Record*. It was the oldest frame commercial building in Northville, constructed in 1830 at the northeast corner of Main and Center Streets. It was later moved to North Center Street and destroyed in a fire in 1929.

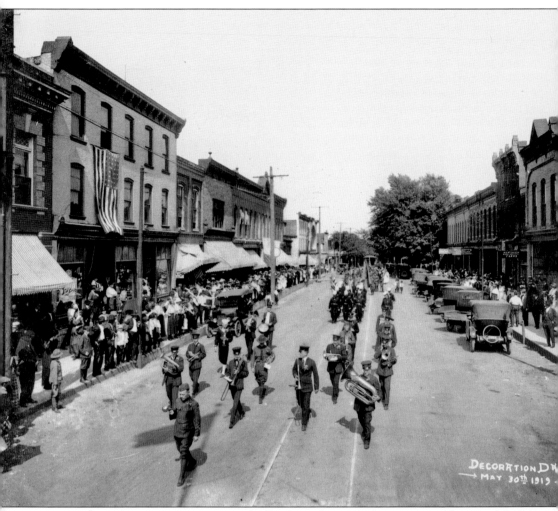

DECORATION DAY PARADE, 1919. Northville's Main Street, looking east, was the site of the May 30, 1919, Decoration Day Parade. This photograph was most likely taken from the Crow's Nest, an elevated platform at the intersection of Main and Center Streets. The band leads parade marchers heading to the center of town for a ceremony at the Crow's Nest. World War I soldiers can be seen behind the band and Masonic Order and in front of the interurban car that is taking up the rear. The parade was the first since the surrender of Germany on November 11, 1918. It was another month before the Treaty of Versailles was signed. Most of the Main Street buildings shown in this picture remain today, including the movie theater (on the left side toward the center), which at that time was called the Alseum. Destroyed by fire, it would be replaced in 1925 by the Penniman-Allen Theatre (P and A). It still exists today as the Marquis Theatre.

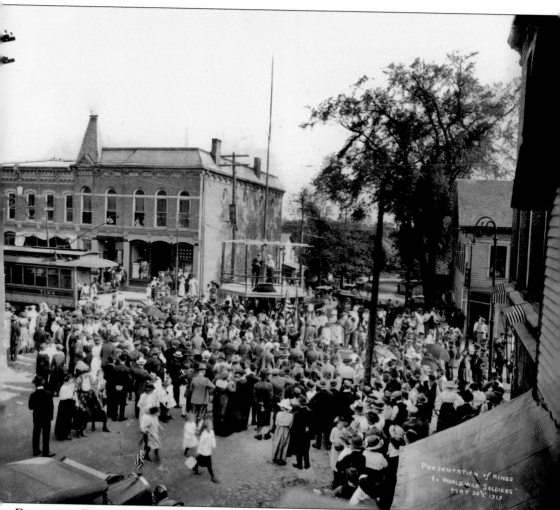

PRESENTATION of RINGS
to WORLD WAR SOLDIERS
MAY 30th 1919

DECORATION DAY CEREMONY, 1919. This photograph, most likely taken from a second-story window on the west side of North Center Street facing south, gives a bird's-eye view of the presentation of rings ceremony for World War I soldiers at the Crow's Nest on May 30, 1919. Veterans and parade-goers crowded around the Crow's Nest for the ceremony. The interurban car can be seen on the left facing West Main Street. At right is the former Park Place Hotel, which would remain at its southwest Main and Center Street location until 1929, when it was destroyed by fire. At that time, it was known as the Northville Hotel and Café and considered the oldest landmark in the village. The B. A. Wheeler grocery, once a mainstay in downtown Northville, can be seen facing left. In 1917, Barton Wheeler retired after 43 years in the grocery business. The brick building he constructed in 1880 remains today and is still managed by the Masonic Temple Association that is headquartered on its second level.

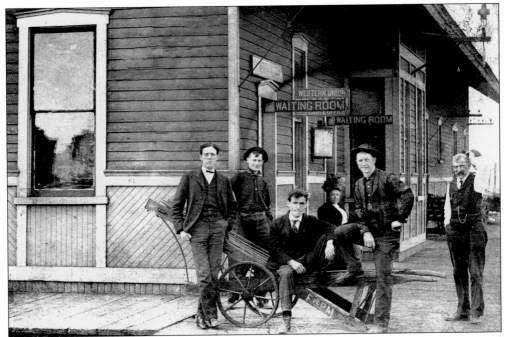

NORTHVILLE TRAIN DEPOT. Northville's railroad depot originally stood on the west side of the railroad tracks along Northville Road. It was built within a month of the first train arrival in Northville on May 27, 1871. The ticket office and waiting rooms were at the north end, with the freight department at the southern end. It also served as the telegraph office for Western Union.

ON THE TRACKS. Handcar workers are photographed on the tracks in front of the interurban depot at the corner of Griswold and Main Streets. Northville travelers used the railroad for distance travel and the interurban for short trips. J. A. Dubuar Manufacturing can be seen in the background.

Five

WHEELS AND WINGS

By the early 1900s, the railroad had long replaced the stagecoach as the dominant mode of transportation, with Northville primarily served by the Flint and Pere Marquette rail line. While the railroad connected Northville to the nation, a more efficient and inexpensive means of transport was making inroads in urban areas: the electric streetcar or interurban. In 1899, the interurban arrived in Northville, with a second line added soon afterward. Fares were 10¢ to Plymouth and 15¢ to Wayne, the central hub for transfers to Detroit or Ann Arbor. It took approximately two and a half hours to travel from Northville to Detroit. The commute was a sharp contrast to the three-day trek the pioneers endured traveling between the two destinations. The advent of the automobile eventually resulted in the demise of the electric streetcar. The interurban between Northville and Detroit was discontinued in 1928.

The emergence of the automobile not only brought Northville a new form of transportation but also a manufacturing opportunity that would have a lasting legacy for the village.

In 1919, automotive pioneer Henry Ford purchased the former J. A. Dubuar Manufacturing Company at the corner of East Main and Griswold and renovated the plant for a valve-making operation. In an effort to bring manufacturing to rural areas so farmers could work in factories when not in the fields, Ford created "village industries." These plants were known for their high craftsmanship and distinguished by their water wheels. The plant began valve production for Model Ts on March 20, 1920. During the next 16 years, the plant would produce 181 million valves. In 1936, a new building was constructed, and by the 1950s, until it ceased operation in 1981, the Northville Valve Plant produced intake and exhaust valves.

In 1927, another transportation pioneer brought innovation and celebrity to Northville when famed pilot Eddie Stinson, "the dean of American aviators," began manufacturing cabin planes at the Stinson Aircraft Corporation. Located in the former Stimpson Scale & Manufacturing Company plant, the aircraft company employed 250 workers before it relocated to Wayne in 1929.

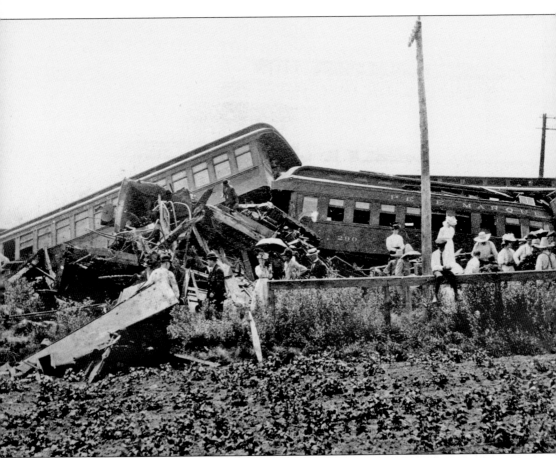

1907 PERE MARQUETTE WRECK. Michigan's worst passenger train collision occurred on July 20, 1907, in Northville Township. An excursion train carrying approximately 600 Pere Marquette employees, their families, and friends collided head-on with a local freight train. The train, consisting of 10 coaches and a baggage car, was traveling from Ionia to Detroit on an annual employee excursion. The train had just passed the Salem station and was about 10 minutes from the Plymouth station when the wreck occurred. Thirty-three people were killed and more than 100 were injured. Six of the coaches and the baggage car were smashed in the wreck. Many local farmers were among the first to arrive on the scene. Physicians from miles around hurried to the crash site. A relief train from Detroit, carrying more physicians and nurses, arrived at the scene to begin transporting the more seriously injured to Detroit hospitals. The scene resembled a battlefield.

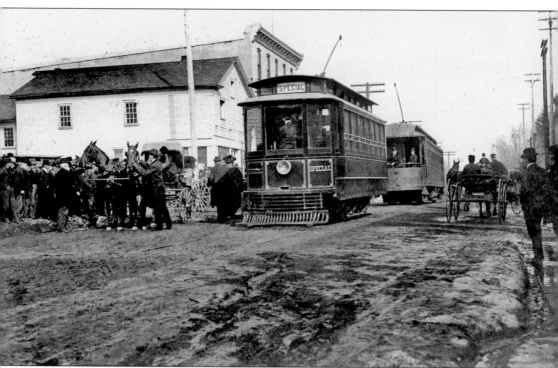

INTERURBAN DEBUTS, 1899. Northville's first electric streetcar arrived on Main Street from Plymouth on November 10, 1899. Regular service began the following day, with complimentary rides given to residents. "The cars were crowded beyond even the standing room capacity with Northville, Plymouth, and Wayne people," reported *The Northville Record* in a November 17, 1899, article. "It seemed that all the Plymouth people were over here, and all of Northville was certainly over at Plymouth. Up till Sunday night more than 1,000 passengers had been carried." This image shows the commemoration of the event. The first car is the private car of F. W. Brooks, president of the Detroit, Plymouth, and Northville Electric Railway Company (DP&N), later changed to the Detroit and Northwestern Railway Company. Not long after the original interurban arrived in Northville, another company added a second line. By 1901, the Detroit United Railway (DUR) consolidated all independent lines into one, and the DP&N became a branch line of the Detroit United Railway.

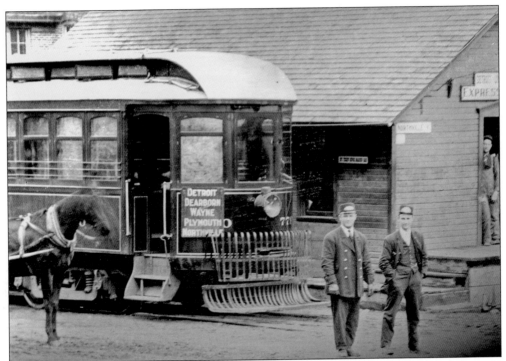

WAITING AT THE DEPOT. The DUR car waits at the depot at the northeast corner of Griswold and Main Streets. Fares were 10¢ to Plymouth and 15¢ to Wayne, the central hub for transfers to Detroit or Ann Arbor. It took approximately two and a half hours to travel from Northville to Detroit and cost 35¢.

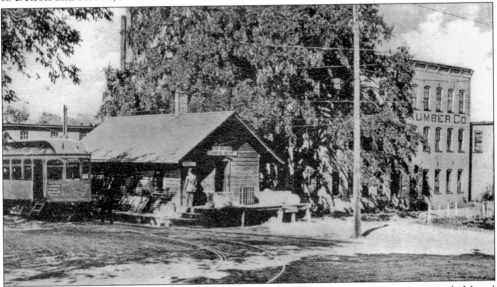

DUR EXPRESS OFFICE, 1913. The DUR station at Griswold and Main Streets provided local farmers with a convenient location to take their produce. A DUR waiting room was located on the west side of North Center Street in a frame building that eventually was replaced by the Schrader Furniture store. The waiting room occupied the lower level of the building, and Lyman "L. L." Ball's photographic studio was on the second floor.

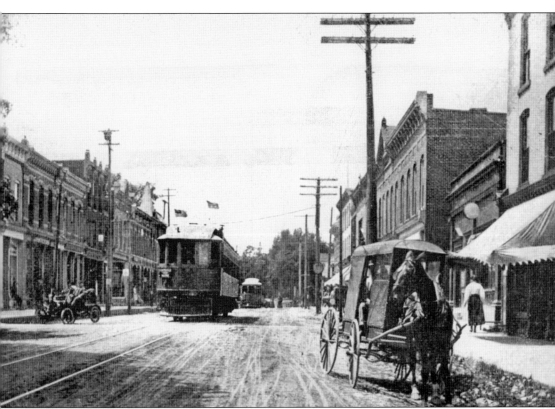

MAIN STREET LOOKING WEST, 1909. Northville's Main Street became an even greater hub of activity once the DUR interurban took to the streets. Horses, wagons, automobiles, and electric streetcars all vied for space along Northville's main thoroughfare. Because the interurban could travel at speeds of up to 60 miles per hour, pedestrian crossings were quite hazardous. The interurban line into downtown Northville ended at the intersection of Main and Center Streets, at the location of the Crow's Nest. Cars coming from both Farmington and Plymouth had to back up to Griswold to turn around. The interurban cars provided riders with an efficient, inexpensive, and comfortable form of transportation. Cars were heated and contained toilets and drinking fountains. Each car had a motorman who occupied a compartment at the front of the car and a conductor who collected fares. The interurban serviced Northville travelers for 30 years until its demise in 1928.

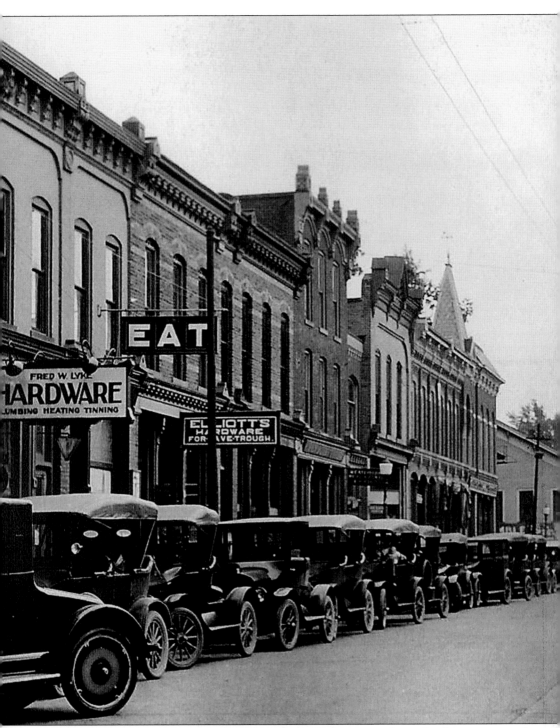

NORTHVILLE, 1920s. This picture of Main Street looking west shows the downtown nearly a century after the first settlers came to Northville. Horses and hitching posts have been replaced with automobiles and curbside parking. The interurban tracks can be seen running through the center of Main Street to the Crow's Nest at the intersection of Main and Center Streets.

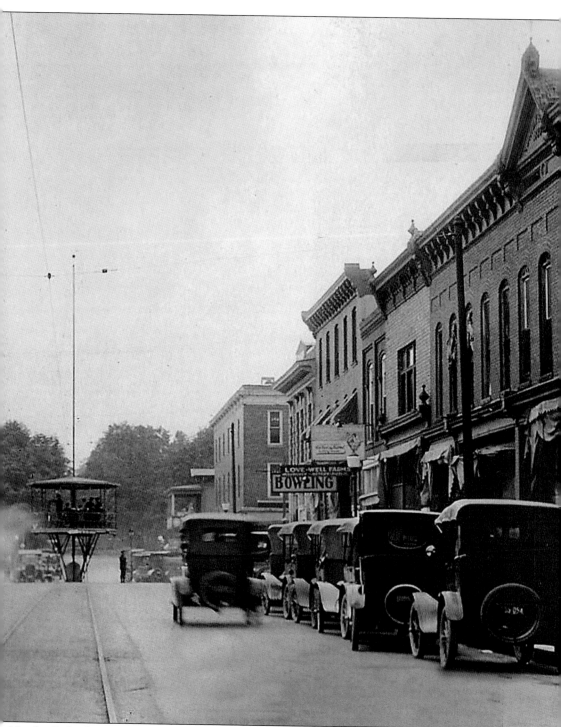

Nearly all the frame structures have been replaced with brick buildings. Restaurants, a bowling alley, hardware stores, and an ice cream parlor are among the retail establishments visible in this photograph. The bell tower in the background at left is the former fire hall.

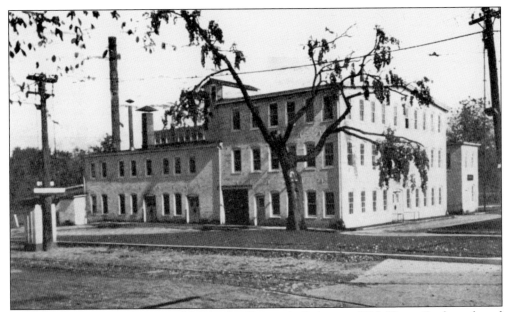

FORD VALVE PLANT, 1920. Upon the death of James A. Dubuar in 1919, Henry Ford purchased the manufacturing operation to use for the production of valves for automobiles and Fordson tractors. After installing a Model T valve production unit and tractor valve–making machinery, the Northville Ford Valve Plant began production on March 20, 1920. Approximately 180 million valves would be produced at the plant during the next 16 years.

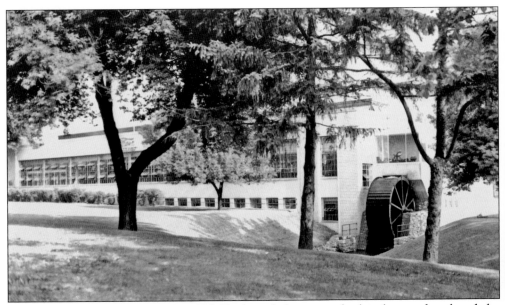

WATER WHEEL PLANT, 1936. By 1936, Ford needed to upgrade the plant and replaced the former Dubuar building with an Albert Kahn-designed structure of brick and steel. The plant is distinguished by its water wheel, a symbol of Henry Ford's "village industries." Though the Northville plant ceased operation in 1981, the building has been redesigned for retail and office space.

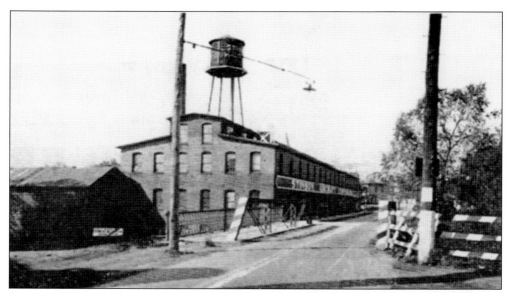

STINSON AIRCRAFT CORPORATION, 1927. Famed pilot Eddie Stinson, "the dean of American aviators," took over the former Stimpson Scale & Manufacturing Company factory in Northville's manufacturing district in 1927 to begin production of his custom aircraft. In addition to the factory, Stinson also purchased property at Six Mile and Beck for an airfield. The aircraft company employed about 250 workers before it relocated to Wayne in 1929.

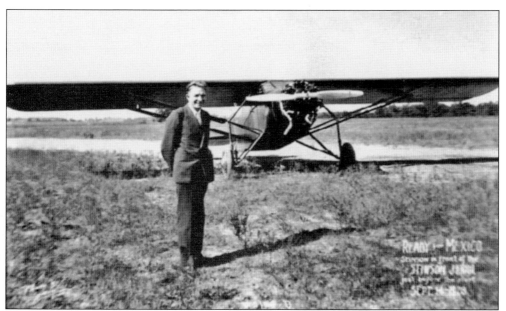

EDDIE STINSON, 1928. Pilot Eddie Stinson is pictured at his airfield at Six Mile and Beck Roads in front of an SM-2 Junior built in 1928. The caption on the photograph reads, "Ready for Mexico, Stinson in front of the Stinson Junior just before the start. Sept. 14, 1928." Stinson lived in Orchard Heights with his family during his time in Northville and was a familiar figure around town.

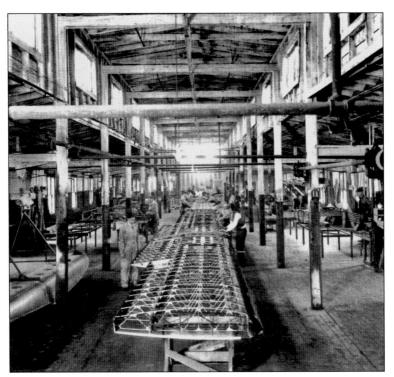

WING PRODUCTION. With a width of nearly 46 feet, wing production required multiple workers to assemble, fit, and glue the nearly four dozen wing ribs. The wings were made of spruce and fitted with steel tubing ailerons. The edges were covered with aluminum before the entire wing was covered in fabric.

WING TAPING. The fabric that encased each airplane wing rib was held together with stitching covered with a pinking tape. The stitching tape was then covered with a sealant called dope to adhere it to the wing and tighten the fabric. Several coats were applied to keep the fabric tight and waterproofed.

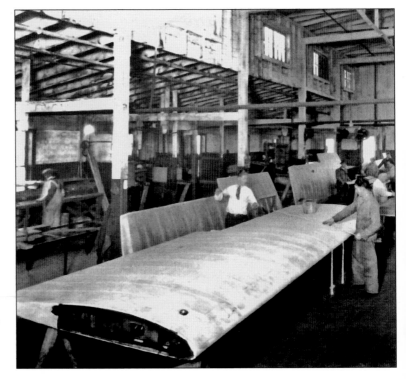

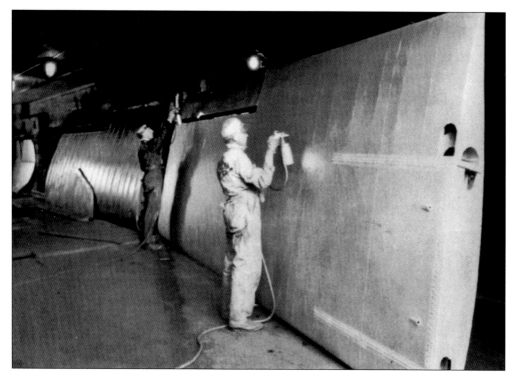

FINAL PAINT COATING. A plant worker applies a finish coat of paint to the bottom side of a wing before assembly. Planes could not be completely assembled inside the Northville plant. They were moved out of the plant minus their wings and towed through town to the Six Mile and Beck airfield for final assembly.

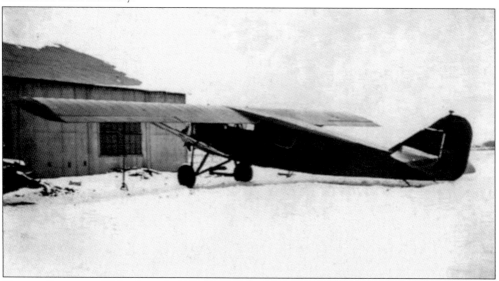

RECORD-BREAKING SM-1. In early 1928, Eddie Stinson set out to break the world endurance record flying a modified SM-1, pictured at the Northville airfield. With his friend George Halderman, Stinson took off from Jacksonville, Florida, at 7:37 a.m. on March 28. They flew a 30-mile course over Jacksonville for the next 53 hours and 37 minutes, landing at 11:40 p.m. on March 30, breaking the old record by more than an hour.

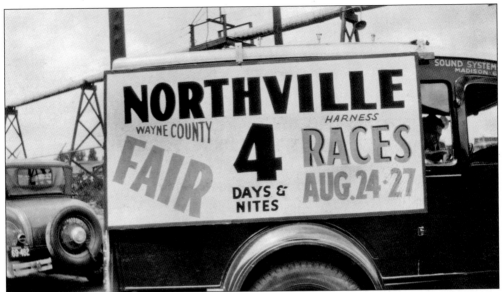

HARNESS RACING DEBUTS. Northville Downs Racetrack had its beginnings at the turn of the early 20th century at a homemade track at Center Street and Seven Mile Road on what was formerly swampland. What started as a nine-hole golf course owned by Ed Starkweather was eventually turned into a modest racetrack. By 1916, it had turned into the Northville-Wayne County Fair and attracted thousands of visitors to the six-day event.

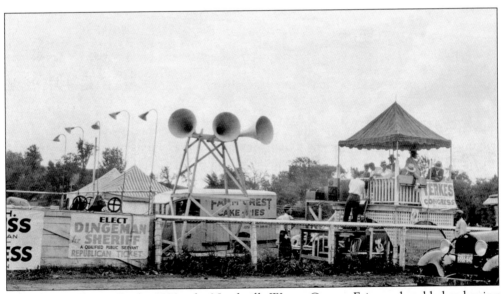

OFF TO THE RACES. By the 1930s, the Northville-Wayne County Fair was heralded as having one of the best half-mile tracks in Michigan. In addition to horse racing, the fair also drew a few celebrities. In preparation for his world championship match against Bob Pastor in 1939, boxer Joe Louis, the "Brown Bomber," used the fairgrounds as his training site. A special boxing ring was constructed for Louis to practice.

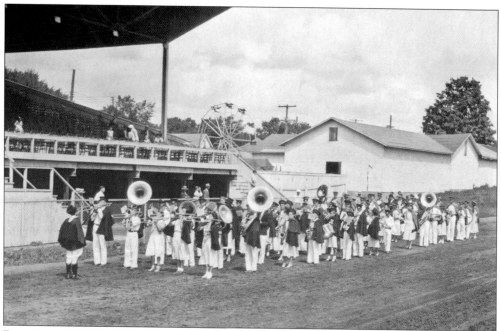

PERFORMING AT THE TRACK. The Northville Community School Band, organized by E. C. Langfield in 1927, takes to the infield at the Northville-Wayne County Fair sometime in the early 1930s. Local bands and musical groups often performed at the six-day event, which was considered an excellent venue to showcase local talent.

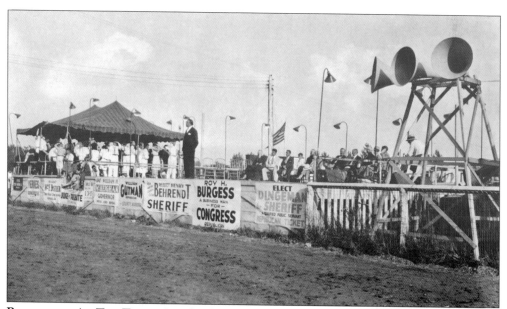

POLITICKING AT THE TRACK. Local politicians found the throngs of crowds at the Northville-Wayne County Fair irresistible—particularly during an election year. In this photograph from the 1930s, candidates line the stage, waiting to say a few words. As indicated by the banners, candidates were seeking a myriad of different offices, from governor to county auditor.

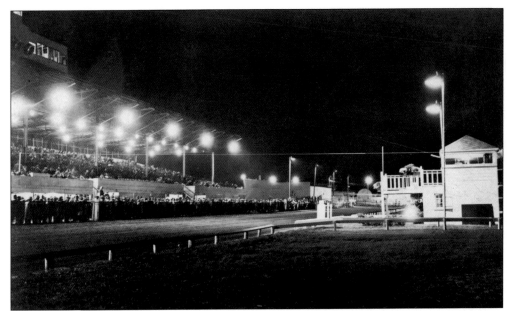

NIGHT RACING DEBUTS. When Dr. Linwood "Doc" Snow, former manager of the Michigan State Fair, took over Northville's Driving Club and the Northville-Wayne County Fair in 1940, racing and fairs were on wane. Snow offered reluctant approval to bring in night racing. On September 1, 1944, the lights went on at the Northville racetrack for the first nighttime harness racing in Michigan. It proved the catalyst to jump-starting the industry.

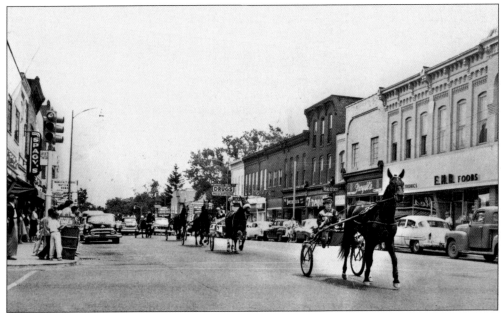

TROTTING DOWN MAIN STREET, 1958. Trotters from Northville Downs Racetrack take to Main Street on their way to the track at Center Street and Seven Mile Road. The downs, which began as a half-mile track at the Northville-Wayne County Fair, gave harness racing a much needed boost with the advent of night racing in 1944. The downs remains a vital part of the community today.

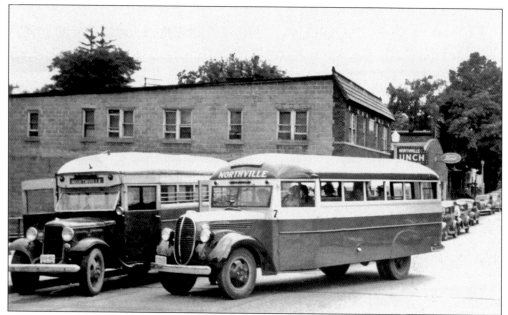

NORTHVILLE COACH LINE. The beginning of bus service in 1925 from Detroit to Northville marked the beginning of the end of the electric streetcar. Though the first bus service was provided by a Detroit company, Northville eventually established its own line. The Northville Coach Line debuted in 1938 and eventually phased out of operation after the Michigan legislature approved a regional transit system in 1967.

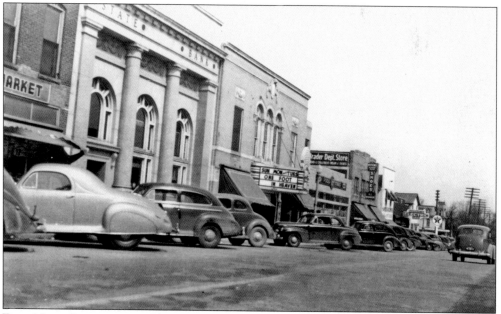

EAST MAIN STREET, 1941. The automobile consumed a larger share of downtown real estate in 1941 than ever before, and parking became a growing concern. Nevertheless, all that would change by the end of the year. On December 7, 1941, the automobile industry turned into an arsenal of democracy, and rationing would put the brakes on gas consumption as Northville and the nation went to war.

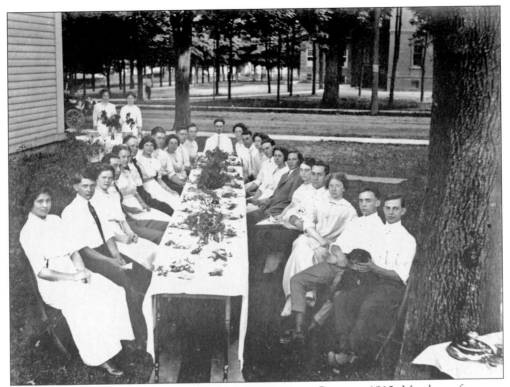

CLASS OF 1912. Members of Northville High School's Class of 1912 are shown at a picnic in celebration of graduation. Among the graduates is August Holcomb, in the dark jacket sixth from the right. The former high school, Northville Union School, can be seen in the background. Holcomb is also pictured with a group of graduates at left (second row). Holcomb would go on to medical school and eventually become a partner in the practice of Dr. Linwood Snow of Northville during the 1930s and 1940s. Snow was a well-respected physician and the former manager of the Michigan State Fair.

Six

LESSONS, LITURGY, AND LEISURE

One-room schoolhouses dotted the farmlands of Northville and its surrounding areas from the mid-1800s to the second half of the 20th century. The Wash-Oak School, located on Currie Road between Seven and Eight Mile Roads, was one of the longest operating of the one-room schoolhouses, remaining open until 1966. In 1975, it was moved to Mill Race Historical Village.

The imposing Northville Union School, built in 1865 as Northville's first high school, was converted to an elementary school when a new high school was built in 1907. The Union School faced Main Street with the new high school built behind it facing West Street, which at that time extended between Main and Cady Streets. Fire would destroy both schools; the Union School in 1916 and the new high school in 1936. Both schools were replaced, and Northville Public Schools would eventually encompass six elementary schools, two middle schools, and a state-of-the-art high school that opened in 2000 on Six Mile Road in Northville Township.

The circuit-riding ministers that preached from the barns and homes of early pioneers were replaced with permanent clergy as Northville's places of worship grew. The Presbyterians organized the first church in 1829, followed by the Methodists in 1834, the Baptists in 1835, and the Lutherans in 1896. It was not until 1922 that a permanent church was built for Northville's Roman Catholic worshippers. All five churches underwent extensive building renovations and new construction to accommodate their growing congregations in the ensuing century.

Northville citizens did not have to go far in search of cultural pursuits. The Northville Opera House, which opened in 1879, was the pet project of *Northville Record* publisher Sam Little. It seated 800 and offered musical entertainment. Northville boasted several bands, including the Northville City Band and the Northville Cornet Band. The Northville City Band often played in the Crow's Nest, an octagon-shaped, elevated bandstand situated at the intersection of Main and Center Streets. In 1925, movies were playing at the Penniman-Allen Theatre at 133 Main Street. It is now the Marquis Theatre, featuring live stage productions and movies.

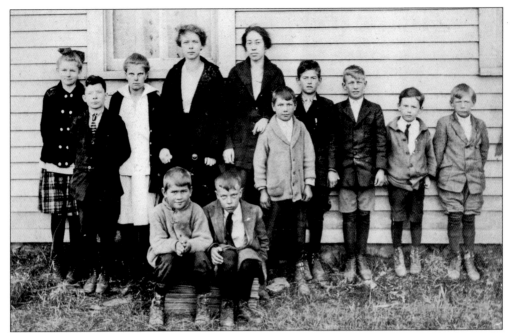

WASH-OAK SCHOOL, 1917. The one-room schoolhouse located on Currie Road was built in 1873 and remained open until 1966. Its name is derived from its location, bordering Washtenaw and Oakland counties. The Class of 1917, from left to right, includes (first row) Roy Miller and William Gyde; (second row) Cleama Smith, ? Huff, Helen Gyde, Ellen Hartman, Miss Kinsler, George Miller, Whitney Merritt, Edward Miller, Knowles Buers, and Martin Miller.

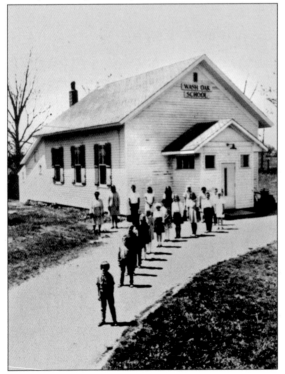

LAST DAY AT WASH-OAK. Students at Wash-Oak School, the last remaining one-room schoolhouse in Northville, line up in the shape of a question mark on their last school day in May 1966. The gesture pointed out the uncertainty regarding the future of the school. It would be left abandoned for many years before Mr. and Mrs. George Rigby donated it to the Northville Historical Society for relocation to Mill Race Historical Village.

FOURTH GRADERS, 1918. Florence Schoultz poses with her class. From left to right are (first row) Frances Hall, Ruth Biery, Hortense Conery, Alice Raymond, Doris Teshka, Arlene Keller, Katherine Kidd, and Esther Ford; (second row) Howard Dixon, Fred Beach, Ed Austin, Vivian Taylor, Elizabeth Riffenburg, Claudine Jacobs, Ruth Sherwood, and Vera Austin; (third row) Roy Hollis, Laurence LeFever, Claude Morgan, Ed Wood, Willie Allen, Kenneth Weston, Marvin Oldenburg, Carlyle Lovewell, and Elseworth Cramer.

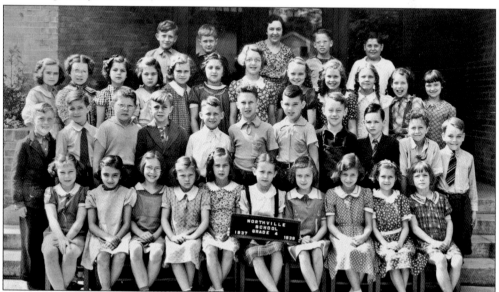

NORTHVILLE FOURTH GRADERS, 1937–1938. The class of May Babbitt poses in front of the elementary school for a class photograph. These elementary students are the first class in the new Main Street Elementary School, built after a fire destroyed the former elementary in 1936. May Babbitt was a member of Northville High School's Class of 1914.

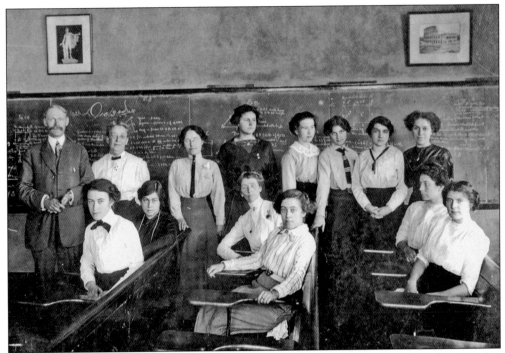

NORTHVILLE TEACHERS, 1913. Pictured in one of Northville's classrooms are, from left to right, (first row, seated) Jennie Withey and Roux Day; (second row, seated) Ruth Martin and Miss Wills; (third row, seated) Garnet Burt and Helen Bullis; (fourth row, standing) Mr. Wheaton, Mrs. Woolley, Florence Miller, Isabella Gordon, Miss Johnson, Grace Pierce, Miss Ramsey, and Margaret Weiler.

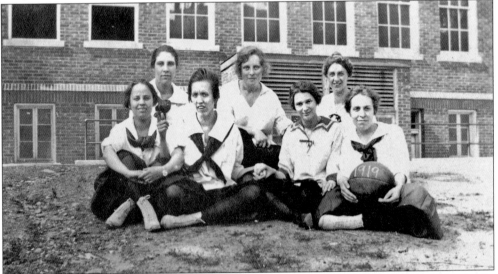

TEACHER RECREATION, 1919. Posing after a basketball game are, from left to right, Northville teachers (first row) Florence Schoultz, Ida B. Cooke, Cecil Elder, and Emma Lori Johnson; (second row) Marjorie North, Peg Meyers, and Margaret Weiler. Ida B. Cooke, a graduate of Northville High School, was a longtime teacher and librarian in the Northville Public Schools. Cooke School, still in operation, is named in her honor.

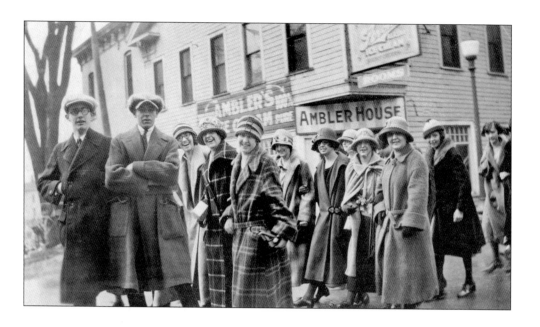

WASHINGTON OR BUST. Members of Northville High School's senior class (year unknown) make their way through downtown to the railroad depot to board the train for their senior trip to Washington, D.C. The trek from the high school on Main Street to the railroad depot on the east side of the railroad tracks off Northville Road highlights several of the village's downtown landmarks. The Ambler House on the southwest corner of Main and Center Streets housed an ice cream parlor offering Stroh's ice cream. The coal office can be seen on the south side of West Main Street. Behind it is the fire hall with its bell tower gracing the skyline. On the north side of the street is Hill's Meat Market (with the two-level porch addition).

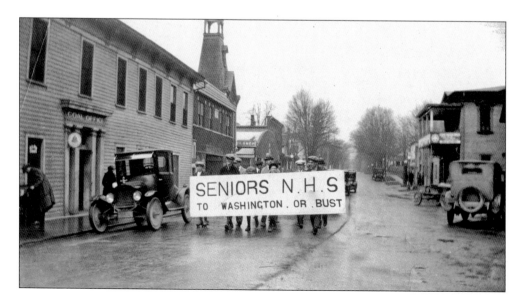

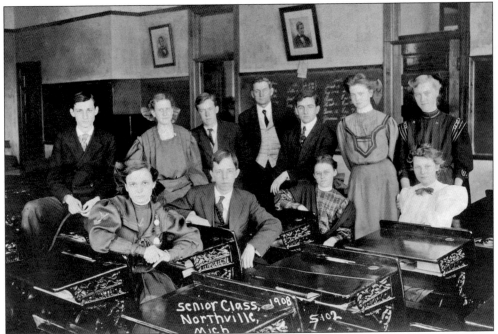

NHS Senior Class, 1908. Members of Northville High School's senior class of 1908 pose in a high school classroom. Among the class members was Bessie Brooks (first row, left). She would marry Howard E. West, a member of the NHS junior class in 1908 (also pictured on this page), in 1916. Bessie would go on to earn her degree and join the faculty of Kansas State College in Manhattan, Kansas.

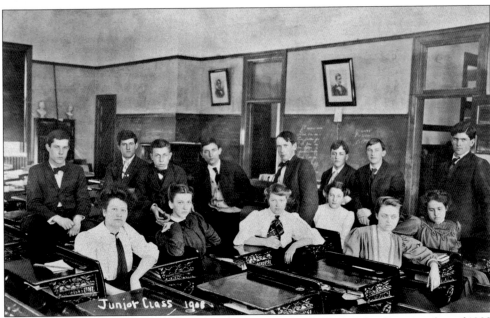

NHS Junior Class, 1908. Among the members of Northville High School's junior class of 1908 was Howard E. West (second row, second from right), who married Bessie Brooks in 1916. A member of Northville High School's football team, Howard died in the influenza epidemic of 1918.

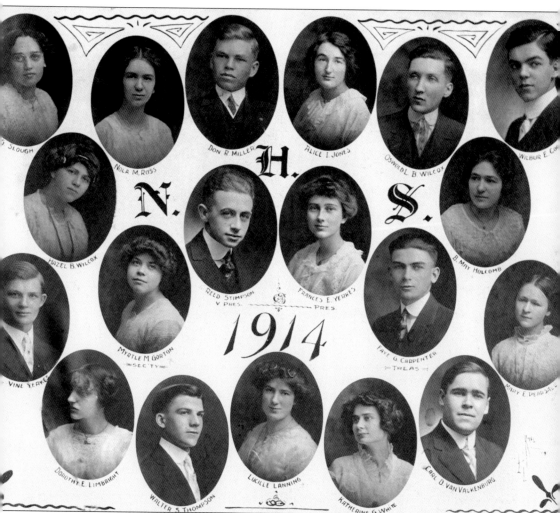

NORTHVILLE HIGH SCHOOL, CLASS OF 1914. This composite from Northville High School's Class of 1914 reflects descendents of some of Northville's early pioneers and most influential families. Among the names in this class are Yerkes, Wilcox, Carpenter, Van Valkenburg, and Stimpson. Also included is B. May Holcomb (third row, far right), who later became May Babbitt. She would become a teacher in the Northville Public Schools and is shown with her fourth grade class of 1937–1938 on page 73. Though still a relatively small graduating class, Northville High School had come a long way since the graduation of Alice Beal, the school's first and only graduate in the Class of 1868. By comparison, there were 564 students in Northville High School's Class of 2009.

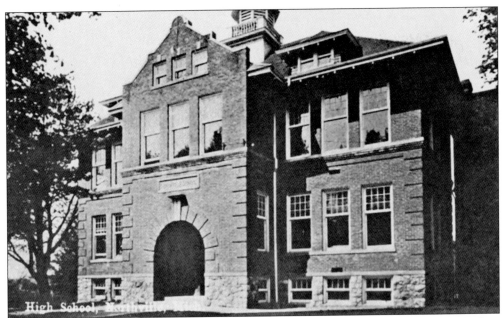

A NEW HIGH SCHOOL. In 1907, construction began on a new high school to alleviate overcrowding at the Union School, which had served as Northville's high school since the 1860s. The school was built on the south side of school property fronting West Street, which at that time continued to Cady Street. It was at the rear of Union School, which faced Main Street. The project cost was $10,000.

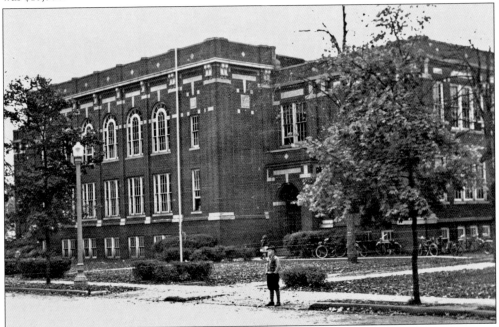

A NEW HIGH SCHOOL, 1916. In less than a decade, Northville would find itself with its third high school. In 1916, a fire destroyed the Union School, which was serving then as the elementary school. The loss resulted in construction of a new school on the site at a cost of $75,000. The 1916 former high school is today's Old Village School.

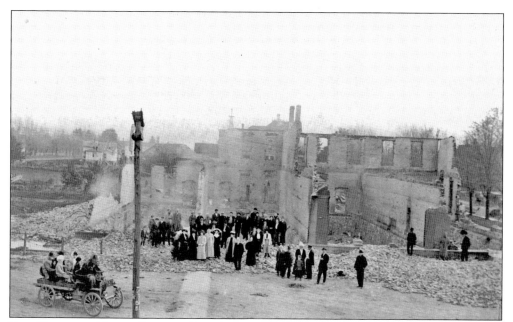

FIRE DESTROYS UNION SCHOOL. Crowds view the devastation of a 1916 fire that destroyed Northville's original high school, Union School, on the site now occupied by Old Village School. The school, with its distinctive cupola, had been a landmark on Main Street since the Civil War. In 1907, a new high school was built to the rear of the Union School and the Civil War–era building became the district's elementary.

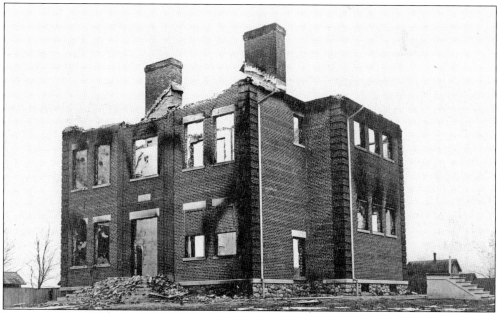

FIRE DESTROYS ELEMENTARY SCHOOL. On January 17, 1936, a fire completely destroyed the elementary school built in 1907 (originally a high school). A nurse at Sessions Hospital on Main Street saw flames coming from the roof and notified the fire department. The fire was believed to have started by sparks from the chimney igniting the rooftop cupola. In July 1936, construction began on a new elementary, Main Street School.

NORTHVILLE HIGH SCHOOL CHAMPIONS, 1927. Northville High School's football team captured the Suburban League Championship in 1927. From left to right are (first row) Charles Lefevre, Louis Tiffin, Terry Thompson, John Leavenworth, and Ted Watts; (second row) Howard Goodale, Bob McCartel, Russell Atchison, Ray Doeksen (coach), Donald "Bean" Ware, Harley Wolfam, and Clausen Murdock.

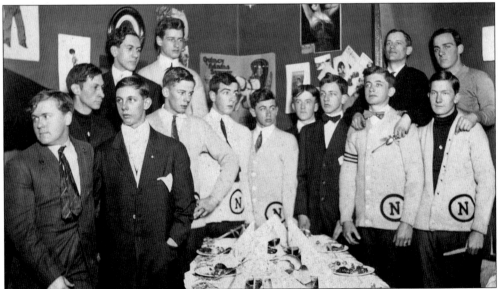

CIRCLE N BASEBALL CLUB. The Circle N Baseball Club was not the earliest baseball team in Northville, but it was one of its most notable. Organized in 1910 and named after the town, it gained a reputation as one of the area's best teams. Pictured at a Circle N gathering are brothers Charles Alonso Schoultz (first row, second from left) and Clyde Harold Schoultz (first row, third from right).

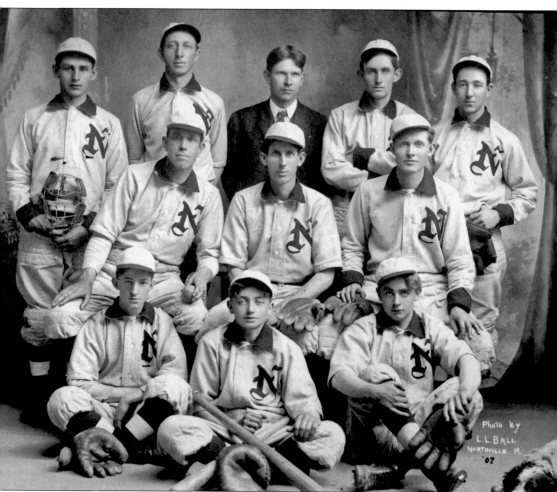

NORTHVILLE BASEBALL, 1907. Northville High School did not have a baseball team in 1907. Instead a group of 10 players who had played together for several years formed a team outside of school called the Northville Juniors. The team was supervised by Dr. T. H. Turner, whose son was on the team, and by R. R. McKahan. Gate receipts paid for new uniforms and equipment. By 1909, the players suggested they play as a high school team during the school year. That year, Northville High School added baseball to its sports schedule. When the school year ended, the team went back to playing as the Northville Juniors and eventually became the Circle Ns. This photograph may represent one of the first Northville Juniors teams. Its players are, from left to right, (first row) unidentified, Earl Stimpson, and Carl Stimpson; (second row) Ed Hinkley, Fred Moffett, and unidentified; (third row) unidentified, Bob Pickles, two unidentified, and Fred Kohler.

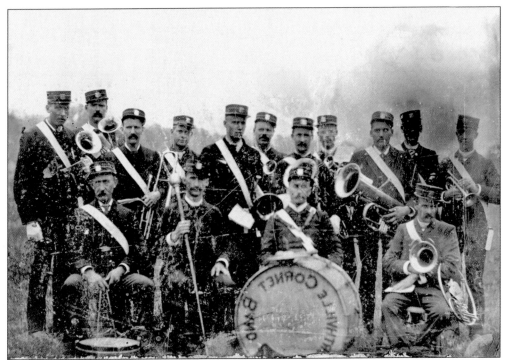

NORTHVILLE CORNET BAND. One of Northville's earliest bands, this popular group of musicians played at a myriad of events, from wedding receptions to village celebrations. When the first train arrived at Northville's railroad depot, it was the Northville Cornet Band that led a parade of railroad employees to the Elliott House for a supper.

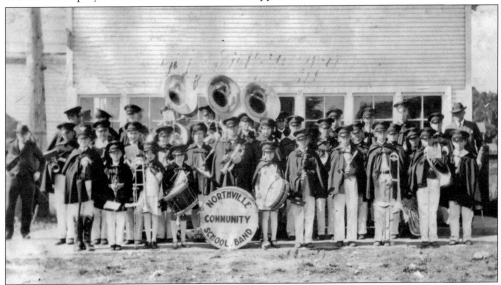

NORTHVILLE COMMUNITY SCHOOL BAND. Founded in 1927 by E. C. Langfield (pictured in the background at left), the Northville Community School Band was comprised of all school-age groups. It played at a variety of community events, including the Northville-Wayne County Fair held at what is now Northville Downs. Langfield was the founder of Northville Laboratories, Inc. manufacturer of flavorings and extracts.

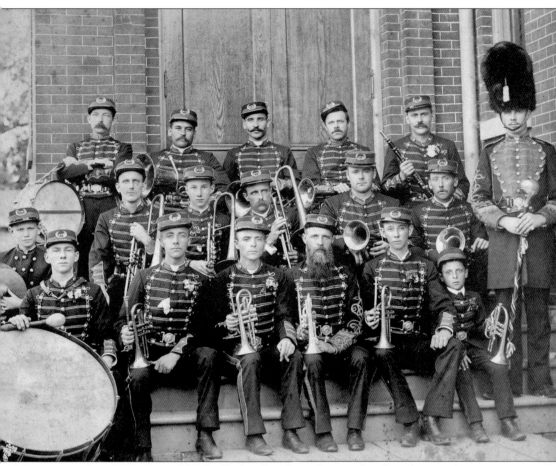

NORTHVILLE CITY BAND, 1887. Northville City Band members, in their best dress uniforms, pose for a photograph in 1887 on the steps of the Methodist church on Center and Dunlap Streets. The leader of the group was Isaac Crocker, "a wizard playing a tripled tongue cornet," according to a reviewer in the local newspaper. The band had a rehearsal room and drill hall at a local skating rink and was invited to play in neighboring cities. Its reputation as one of the finest bands in the area kept its members busy with a variety of engagements. It frequently returned home with trophies from local competitions. On Saturday nights, it played at a skating rink or dance hall. Like all other Northville bands, it also played in the Crow's Nest, the elevated bandstand at the intersection of Main and Center Streets. The drum major (second row, far right) was William E. Hakes.

First Presbyterian Church. This image of Northville's earliest church was taken in 1942. At that time, the First Presbyterian Church already had been in existence for 113 years. Organized in 1829, its first small, wooden church was constructed in 1831 on land donated by Daniel Cady. In 1838, a theological split within the Detroit Presbytery created two factions within the church: the old-school conservatives and the new-school liberals. The new-school members organized a second Presbyterian church and constructed the New School Church, now located in Mill Race Historical Village. The old-school members moved the original wood structure to the rear of the church site and constructed a new brick building in 1845. The church building has changed radically since the church's beginnings. After 1845, the building changes included the addition of a new sanctuary, construction of a fellowship hall, construction of a Christian Education wing, and much more. An organ installed in 1922 was a gift from Andrew Carnegie.

UNITED METHODIST. Established in 1834, the Methodists built the original church facing the east side of Center Street. Its building was a simple frame structure. In 1885, a cornerstone was erected for a new church building on the southwest corner of Center and Dunlap Streets. In 1968, the church was moved to a new location at Eight Mile and Taft Roads.

REV. WILLIAM RICHARDS. During the first half of the 20th century, the Methodist church membership doubled. In 1928, a new fellowship hall was constructed and named after the Rev. William Richards, a beloved pastor who served from 1922 to 1931. (Courtesy of Richard Ambler.)

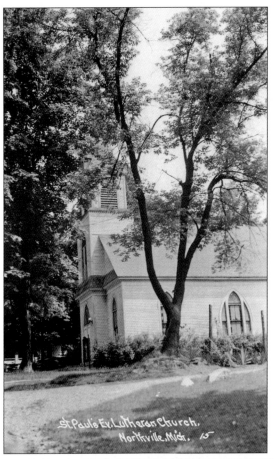

St. Paul's Ev. Lutheran Church,
Northville, Mich. 15

ST. PAUL'S EVANGELICAL LUTHERAN.
Organized in 1896, St. Paul's Evangelical
Lutheran Church was originally located
on Nine Mile and Taft Roads. At that
time, religious services were in German.
The church moved its location to
downtown Northville in 1897, building
a permanent church and separate
schoolhouse on a 4-acre site at Elm
and High Streets. It continued separate
services in English and German. The
original frame church was modified
in 1930, but growth in membership
necessitated a new church in 1950. It
included the cornerstone of the original
church in the narthex and the bell
from the old church. The bell, cast by
Northville's American Bell and Foundry
Company, weighed 1,250 pounds. It
was dedicated in 1907. In 1959, the
church added a two-level building for a
Christian day school with an addition
to the school added in the 1970s.

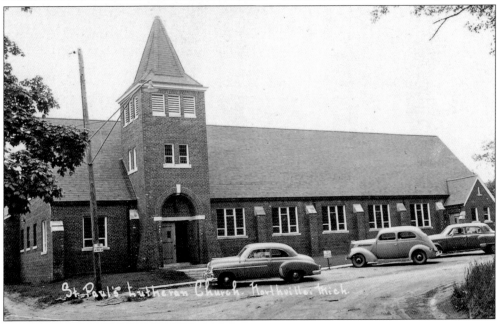

St. Paul's Lutheran Church, Northville, Mich.

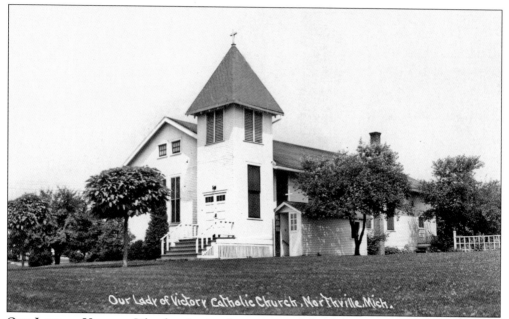

Our Lady of Victory Catholic Church, Northville, Mich.

OUR LADY OF VICTORY. Like the circuit-riding pastors of the early 1800s, Catholic priests from Milford celebrated mass in the homes of Northville parishioners beginning in the late 1880s. In 1922, land was purchased, and a frame building was dedicated at Orchard Drive and Thayer Boulevard, site of the present church. The first Catholic school was built in 1952, and a new church and social hall were constructed in 1957.

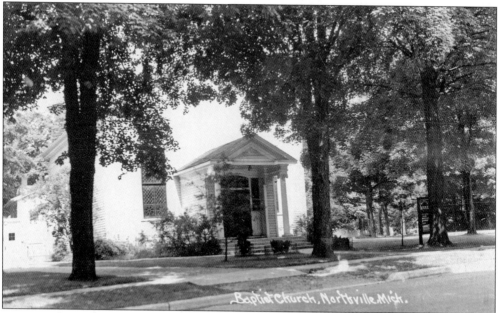

Baptist Church, Northville, Mich.

FIRST BAPTIST CHURCH. The first location of the Northville Baptist Church was on Taft Road, 2 miles west of town. Services were held in a small log building. The first constitution was written June 18, 1835. In 1844, William and Sarah Dunlap deeded the church site, consisting of a half-acre of land at North Wing and Randolph Streets, to the Baptist society. The present church building was dedicated in 1859.

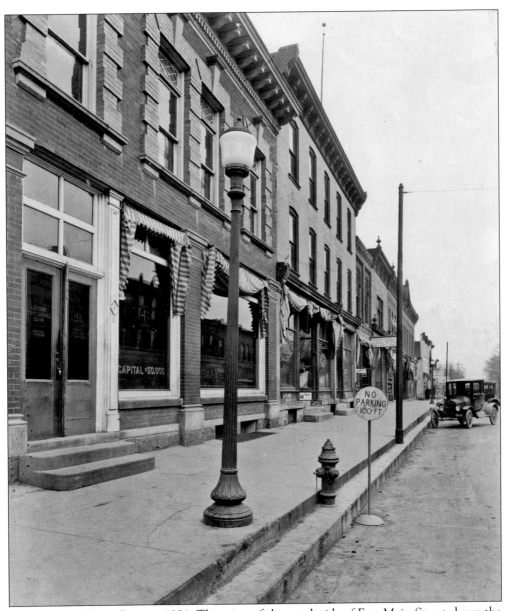

NORTHVILLE'S MAIN STREET, 1921. This view of the north side of East Main Street shows the evolution of the downtown from predominantly frame clapboard structures in the village's infancy to an entire block of nearly all brick facades. One of the distinguishing features is the elevation of the street to the sidewalk and the front steps to each of the building entryways. Gone are the hitching posts, replaced by parking signs. The building in the foreground at left is the Lapham State Savings Bank. Additional retailers on the north side of Main Street are Spagnuolo and Martino Fruit Stand and E. C. Hinkley's Bowling and Tobacco store. Most of the buildings along this stretch of Main Street remain today. This photograph was taken in 1921, just a few years shy of Northville's Centennial, which would occur in 1927.

Seven

CITY INCORPORATION

Northville weathered the first half of the 20th century like much of the nation, surviving the Great Depression and two world wars. Despite the calamitous state of world affairs, Northville continued to be a destination for many. The 1960 census showed the city's population climbed from 3,297 in 1950 to 3,865 in 1960.

One of the most significant events in Northville's history occurred on May 23, 1955, when voters approved city incorporation, forever changing the village status it held since 1867. In December 1955, voters approved a new city charter, and Claude N. Ely was elected the city's first mayor. Among the advantages of becoming a city was increased revenue from the state. It was noted that had Northville been a city, it could have taken advantage of $330,00 in revenue from Northville Downs.

Northville Downs, which had rather humble beginnings in the early 1900s, became a dominant force in the harness racing industry. Dr. Linwood Snow, a longtime Northville resident and former manager of the Michigan State Fair, took over the Northville Driving Club in 1940 and shepherded in the first night horse racing in Michigan in 1944. The advent of night racing proved a boon for harness racing and for Northville Downs, which survives today.

The mid-1950s through mid-1970s would bring changes to the landscape of the community, as longtime institutions faced their demise. In 1963, the 119-year-old former Lapham residence, which had housed the village and city chambers, offices, and police department since 1926, was razed to make way for a new city hall at the same location.

Two former medical institutions also closed, as medical advancements deemed them obsolete: Maybury Sanatorium, a renowned facility for the treatment of tuberculosis located on Beck Road between Seven and Eight Mile Roads, and Eastlawn, a privately owned tuberculosis sanatorium on High Street founded by Dr. A. B. Wickham. Maybury's buildings were eventually demolished to make way for Wayne County's first state park. Eastlawn was turned into a convalescent center in the 1950s and demolished in 1976. The site is now home to Allen Terrace, a municipally owned senior citizens housing development.

WILCOX HOUSE. Early settlers George Henry Wilcox and Lona Malvina (Jones) Wilcox built this home on the southwest corner of South Wing and Cady Streets. George owned a shoe shop on the upper level of a building on Cady Street. Daniel Johnson, who operated a blacksmith shop on the lower level, owned the building. The Wilcox house was demolished in 1951 to make way for the present post office.

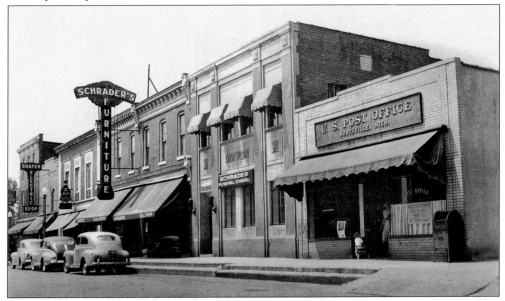

CENTER STREET POST OFFICE, 1946. The U.S. Post Office occupied space in a multitude of downtown buildings before it found permanent space at its present location on South Wing Street. One of the first post office locations was on the southeast corner of Main and Center Streets, visible in an 1860s photograph on page 10. From the Center Street location, the post office would move to its current site in 1951.

VILLAGE HALL, 1926–1963. The former Lapham homestead that stood at West Main and South Wing Streets was sold to the Village of Northville in 1926 and became the village hall. It served as the village municipal offices and police station for 37 years. In 1955, residents approved city incorporation, and in 1963, the former village hall was razed to make room on the site for a new municipal complex.

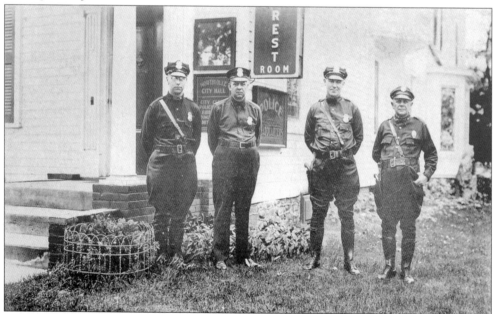

NORTHVILLE CITY POLICE. Members of Northville's city police department posed in front of the old city hall before it was demolished to make way for the new municipal offices, library, and police and fire departments. The picture was taken sometime between 1955, when Northville voters approved city incorporation, and 1963, when the old city hall was torn down.

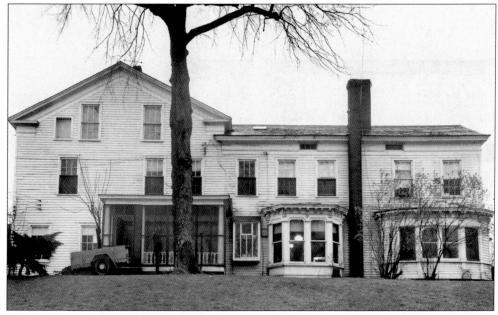

LAPHAM HOMESTEAD, 1844–1963. The enormity of the Lapham homestead at the southwest corner of Main and Wing Streets can be seen in this photograph taken from the park just south of the site. Architect David Gregory built the house for Jared S. Lapham; his wife, Martha Gregory Lapham; and their children, Mary and William. Jared Lapham owned J. S. Lapham and Company Bank.

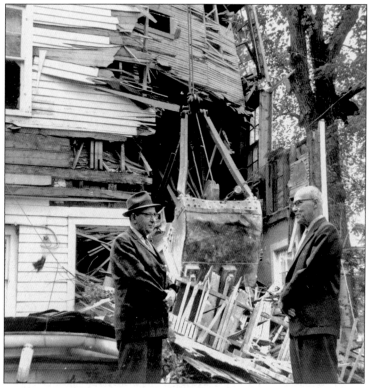

LAPHAM HOMESTEAD RAZED. The former Lapham Homestead was razed in 1963 to make room for a new city hall complex. Surveying the demolition are city mayor A. M. Allen, left, and former village president Elmer Smith. At the same time the former Lapham home was razed, the fire hall on West Main Street was also demolished. The fire hall, with its bell tower, can be seen in photographs on pages 60–61 and 75.

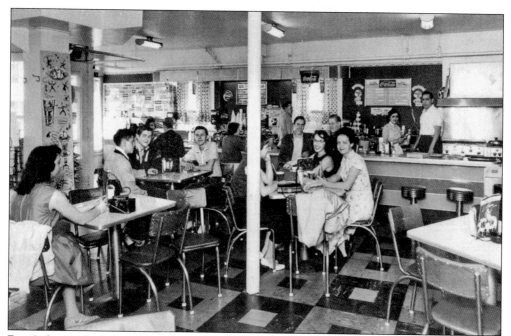

PAUL'S SWEET SHOP, 1957. Located at 144 East Main Street in a building that dated to the first half of the 19th century and was the village's first library, Paul and Mamie Folino operated Paul's Sweet Shop beginning in 1957. A popular hangout for high school students, the restaurant was the first in Northville to offer pizza pies.

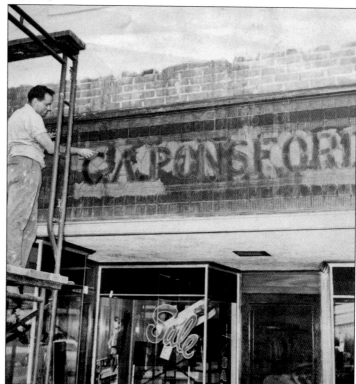

UNCOVERING PONSFORD'S, 1950s. Jim Lapham uncovers the original sign on the facade of his family's retail store on East Main Street during a 1950s renovation. Jim and his brother, Charles, are grandsons of Charles A. Ponsford, who founded C. A. Ponsford's dry goods store in 1910. The East Main Street building is still owned by Charles Lapham, who continued the family business until the 1990s. (Courtesy of Charles P. Lapham.)

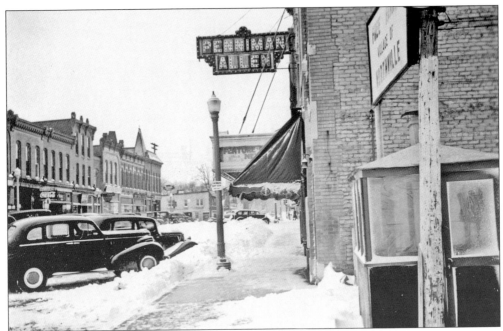

WHITE OUT, 1939. A 1939 snowstorm blanketed downtown Northville. This photograph shows East Main Street looking west toward Center Street. At right is the Penniman-Allen Theatre. The small structure in the forefront at right is Ware's caramel popcorn stand. (Courtesy of Fred Hicks.)

WEST MAIN STREET, 1939. Automobiles take to the snow-covered streets of West Main Street. Pictured on the south side of West Main are, from left to right, the Perrin building, the Cottage Inn, and the Ford garage. The top of the Northville Library can be seen over the rooftops. (Courtesy of Fred Hicks.)

CHEVROLET DEALERSHIP OPENS. Kenneth Rathburn, a former cashier for the Marquette Railroad in Plymouth, took a gamble in the midst of the Depression by opening a Chevrolet dealership at 122 West Main Street, between Wing and Center Streets. He opened the dealership downtown in 1932. Twenty years later, he expanded the business and moved Rathburn Chevrolet Sales to 560 South Main Street. (Courtesy of Fred Hicks.)

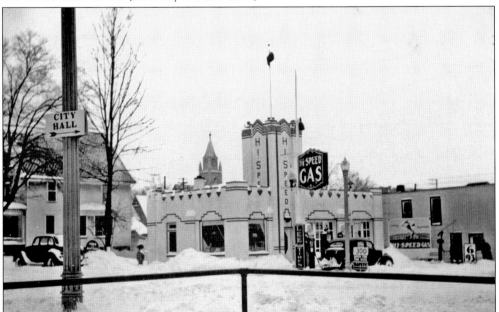

HI-SPEED STATION, 1939. The art deco design of the Hi-Speed station on the northeast corner of Wing and West Main Streets was something of a contrast to the 19th-century structures lining downtown. The steeple of the Methodist church can be seen beyond the roof of the gas station. The station was eventually demolished to make way for a municipal parking lot. (Courtesy of Fred Hicks.)

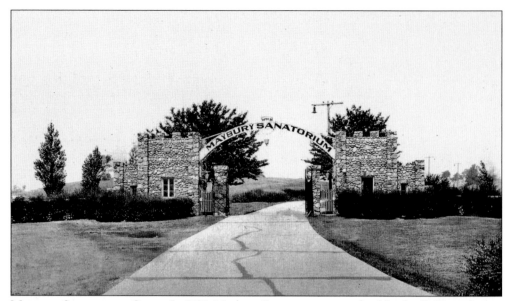

MAYBURY SANATORIUM OPENS. In 1921, Maybury Sanatorium opened in Northville Township on a 900-acre site bounded by Seven and Eight Mile Roads and Beck and Napier Roads. Under the direction of William Maybury, for whom the facility was named, the sanatorium would become a leading center for the treatment of tuberculosis.

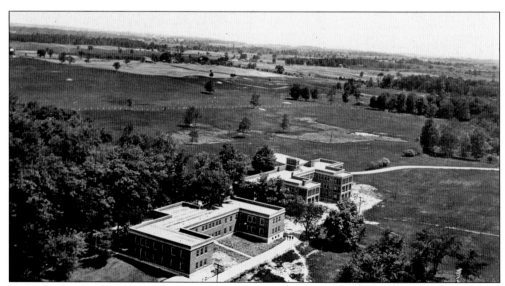

NORTHVILLE'S LURE. The natural beauty and pastoral setting of the 900-acre Northville Township site offered the atmosphere necessary to treat the thousands of patients housed at the Maybury Sanatorium during its existence. Tuberculosis, most easily transmitted in cramped, unsanitary conditions, was most prevalent in urban areas—particularly big cities such as Detroit.

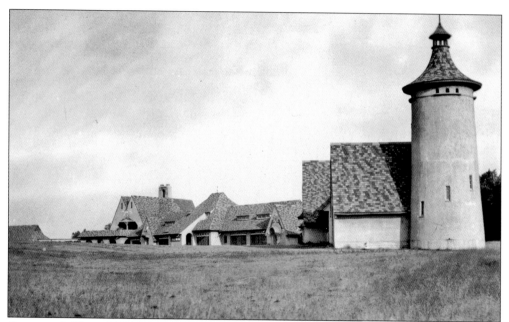

CHILDREN'S UNIT. At William Maybury's insistence, a children's unit was established at Maybury to provide a home-like setting for the children being treated at the facility. The wooded, park-like setting, schoolhouse, farm, red-brick houses, and a theatrical stage all helped make children feel welcome and promoted a healthy environment for fighting the ravages of tuberculosis.

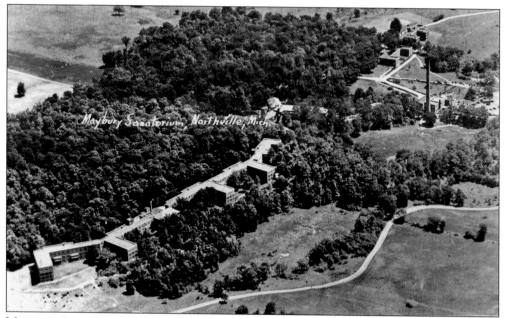

MAYBURY AERIAL VIEW. This photograph of Maybury Sanatorium shows the expanse of property stretching over 2 square miles. There were 45 buildings erected on the site, with only a few remaining today. The property was sold to the State of Michigan in 1973, and the buildings were razed to accommodate the first state park in Wayne County—Maybury State Park.

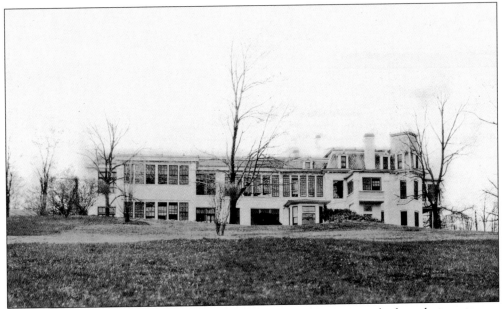

EASTLAWN SANATORIUM. Northville became the location for yet a second tuberculosis treatment facility when Dr. A. B. Wickham purchased the former estate of John Buchner, located on what is now Allen Terrace. Wickham utilized the former Buchner mansion and then put on a substantial addition for patients, creating Eastlawn, a privately owned tuberculosis sanatorium.

DR. A. B. WICKHAM. Dr. Wickham was a specialist in the treatment of tuberculosis. He was an advocate for the "home treater" technique for treating tuberculosis, encouraging patients to construct sleeping porches to promote ideal conditions for rest in the open air. In 1930, Dr. Wickham became ill, and Dr. Royce Shafter joined the operation, eventually becoming the sole owner.

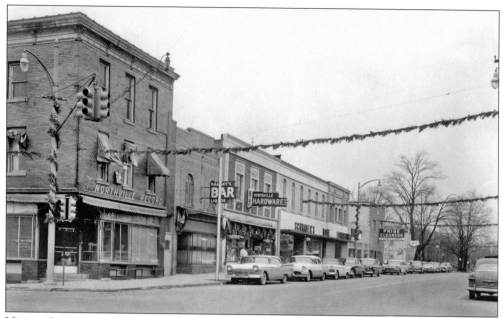

NORTH CENTER STREET, 1956. *The Northville Record* building dominates the west side of North Center Street in this 1956 photograph. Bill Sliger, then the new owner of the newspaper, purchased the building that year when he bought *The Record* from Glenn C. Cummings. Other businesses on the street include Ramsey's Bar, Northville Hardware, Schrader's Home Furnishings, and Pride Cleaners.

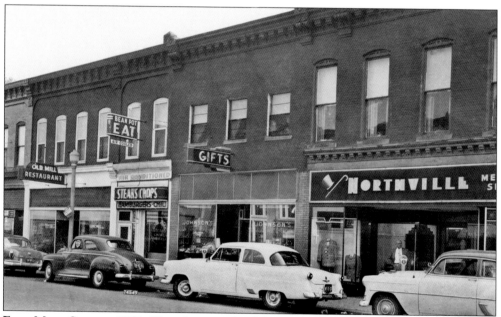

EAST MAIN STREET, 1952. This photograph of the south side of East Main Street illustrates changes in building facades during the last half-century. Businesses shown include the Old Mill Restaurant, The Bean Pot, and Northville Men's Shop, owned by Charles A. Lapham. The business was an extension of the dry goods store opened in 1910 by Lapham's grandfather, C. A. Ponsford, at the same location. (Courtesy of Charles P. Lapham.)

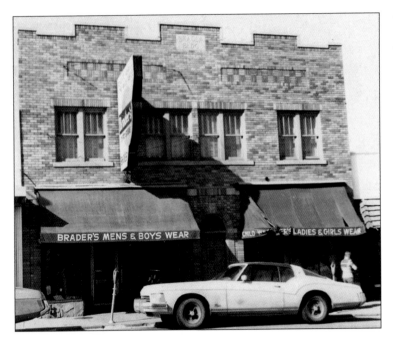

BRADER'S. After moving out of the Northville Opera House in 1928, Sam and Mary Brader opened their department store at this site on North Center Street. Brader's Department Store was a downtown mainstay for more than 50 years, even after the Brader family sold the business.

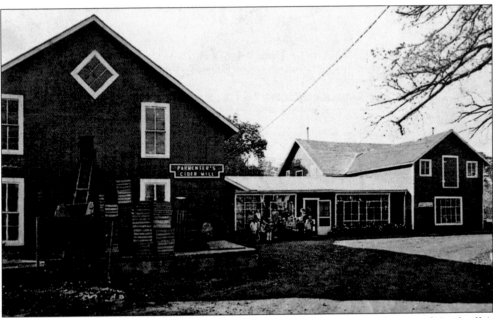

PARMENTER'S CIDER MILL. Founded in 1873 by B. A. Parmenter, the cider mill is one of Northville's oldest businesses. It continues to draw tens of thousands of visitors during cider season from September through November. Though the Parmenter family sold the business in 1968, its subsequent owners have maintained its quality and tradition.

NORTHVILLE LABORATORIES, INC. Founded by E. C. Langfield in 1914, Northville Laboratories at 501 Fairbrook Street has been manufacturing flavorings and extracts—most notably vanilla—for nearly a century. Conrad Langfield took ownership of the company before his father's death in 1936. It remained under family ownership until it was sold in 1966. The Northville Laboratories name remains, though Jogue, Inc. acquired the company in 1991.

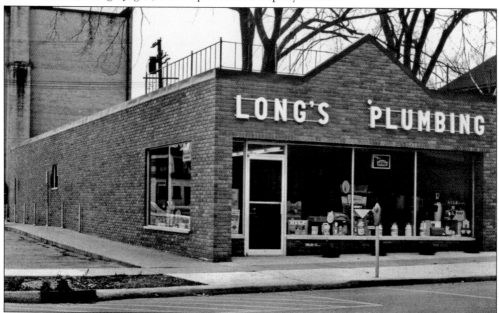

LONG'S PLUMBING. Glenn and Lois Long established their plumbing business out of their Northville home in 1949. After opening the first office on Seven Mile Road in 1953, Long's moved its operation to a Dunlap Street location, shown in the photograph, and then to its current office and showroom site on Main Street. Glenn's son, Jim, and granddaughter, Allison, manage the company. (Courtesy of Jim Long.)

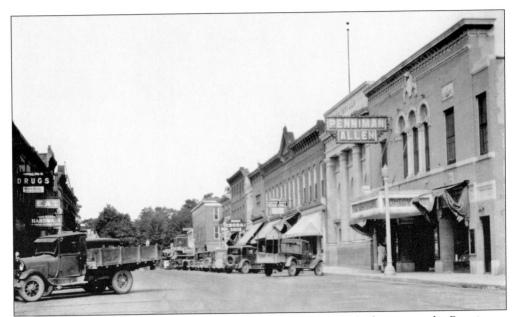

MAIN STREET LOOKING WEST. In this photograph of Main Street looking west, the Penniman-Allen Theatre can be seen in the foreground on the left. Opening in 1925, the theater showed movies for the first 25 years. In the 1970s, the former movie house was restored and reopened as the Marquis, featuring live children's theater. The Marquis also shows classic movies on Saturday nights . . . a throwback to its roots.

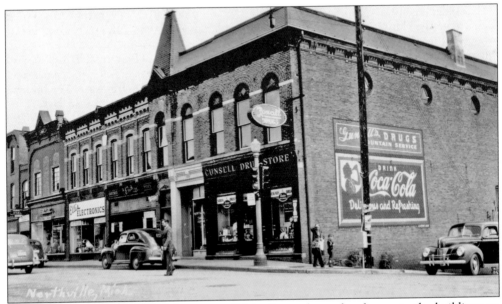

MAIN STREET LOOKING EAST. This view of Main Street shows the change in the buildings on the south side of East Main Street. B. A. Wheeler's grocery has long been replaced. Among the new tenants of the former Wheeler building are Gunsell Drugstore, a shoe repair, Emil's groceries and meats, Ellis Electronics, Freydl's Cleaners, and the coal office.

Eight

ENLIGHTENMENT AND ADVOCACY

As Northville's population grew, the character of the community was defined not only by its thriving businesses but the establishment of numerous clubs and organizations that provided cultural, educational, and philanthropic support to its citizens.

The oldest organization traces its roots to 1866, when the Grand Lodge of Michigan granted a charter to the Northville Lodge No. 186, Free and Accepted Masons. Originally meeting over what was then W. P. Hungerford's store at the northeast corner of Main and Center Streets, the Masons moved in 1880 to permanent quarters on the second floor of Barton M. Wheeler's brick building at the southeast corner of Main and Center Streets. Wheeler, himself a Mason, agreed to let the organization construct a second floor and enter into a long-term lease. The Masonic Temple Association of Northville was formed that same year to manage and maintain the building. Northville Lodge No. 186 continues to meet there today.

Other organizations with their roots in Northville's first century are the Northville Woman's Club founded in 1892; Meadowbrook Country Club founded in 1916; American Legion-Lloyd H. Green Post 147 in 1919; Northville Rotary Club in 1926; and the Sarah Ann Cochrane Chapter of the Daughters of the American Revolution in 1926. Longtime organizations also include the Mothers' Club of Northville founded in 1935 and Northville VFW Post 4012 chartered in 1945.

Northville's women have been an indomitable force in shaping the community. The Northville Woman's Club was organized by Lucy Stout Dowd, the club's first president, and began as a literary study group. The following year, Mary E. Lapham was elected president. One of Northville's most prominent citizens and a bulwark in the formation of the Ladies Library Association, Lapham provided the woman's club with a permanent meeting place in the library on Wing Street that she had deeded to the association.

The threat of demolition of the former Lapham library in the 1970s pushed the Northville Woman's Club to the forefront of Northville's historic preservation efforts. The club would be instrumental in the formation of the Northville Historical Society and its development of the Mill Race Historical Village.

MOLLY S. YERKES. Molly Yerkes was the wife of Robert Yerkes, a prominent businessman and descendent of one of Northville's earliest pioneers. Molly was among the more than dozen Yerkes women who were members of the Northville Woman's Club founded in 1892 by Lucy Stout Dowd, its first president. The year before the organization's official incorporation, Dowd gathered together a few women to study women of history, literary works, and current events. Those small group gatherings marked the beginnings of the club. For many years, the woman's club had a permanent home at the Northville Library, a gift from its second president, Mary Lapham, who gave the historic former church opposite her family's homestead on Wing Street to the Ladies Library Association for the village library. A provision was made for the Northville Woman's Club to use the library for its meetings. The club eventually outgrew the library and moved its meetings to the First Presbyterian Church, where it continues to meet today.

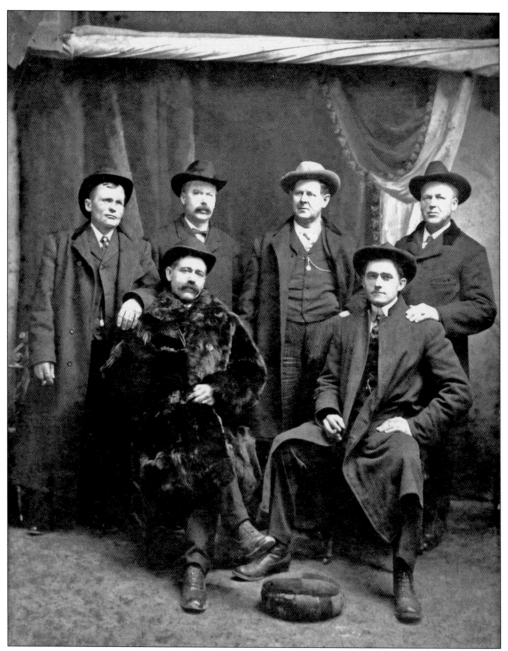

NORTHVILLE GENTLEMEN. Posing in their finest are, from left to right, (first row) Marion A. Porter and O. Porter; (second row) Capt. ? Kurth, Bert Stark, Alie Carpenter, and Wilbur Stark. Marion Porter owned Sands and Porter furniture dealers and funeral parlor (later M. A. Porter Furniture and Undertaking) on Center Street. He also operated the first telephone company in Northville and owned one of the first automobiles in the village. Wilbur Stark owned a downtown grocery store in the early 1900s. The Wilbur Stark and Marion Porter families were neighbors on Dunlap. The Stark's home had a barn occupied by two horses, a family carriage and a cutter that carried the family up and down the unpaved roads on Dunlap Street. Marion Porter used his barn to store his Maxwell automobile.

BACKYARD CARDS AT THE STARK HOME, C. 1906. This gathering was at the home of George and Eliza Stark on Main Street. The hostess was Estelle "Stella" Stark, standing at far left. Also identified is Emma Cole Stark, third row, sixth from left. Emma's husband, Wilbur Stark, is pictured on page 105. Mae Filkins is in the third row, fourth from left, and Maree Stark (Congo) is in the first row, far left.

FAMILY PORTRAIT? The only identified member in this group portrait is Helen Whipple, second row, second from right. Helen was married to Howard Whipple, who owned a farm at the northeast corner of Seven Mile and Napier Roads. Howard Whipple furnished William Maybury with a team of horses and helped him plow a single furrow to mark the roads for the development of Maybury Sanatorium.

Anna McRae Atchison.
Anna Atchison was the wife of Dr. Russell E. Atchison and the mother of Dr. Russell A. Atchison. The former superintendent at the University of Michigan's Homeopathic Hospital, Russell E. Atchison opened an eight-bed hospital on Dunlap Street in 1924. It also served as the family residence. Anna, a former nurse at University of Michigan's Homeopathic Hospital, is pictured at her Dunlap home. (Courtesy of Richard Ambler.)

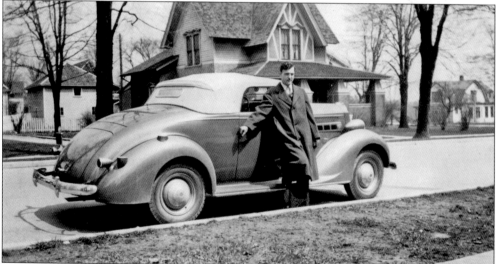

Dr. Russell Atchison. A member of the Northville High School champion football team in 1927 and salutatorian of the Class of 1928, Russell Atchison would earn a medical degree from the University of Michigan and take over his father's medical practice at the Atchison Clinic on Dunlap Street. He practiced medicine in Northville for more than 50 years. (Courtesy of Richard Ambler.)

Up On The Roof, 1890s. Pictured on an outbuilding behind their Wing Street home, the Clarkson sisters are, from left to right, Anna, Norine, Flora, and Mabel. The sisters were the daughters of Charles Eugene and Eveline Manning Clarkson and the granddaughters of Northville pioneers David and Sarah Clarkson. (Courtesy of Troy Schmidt.)

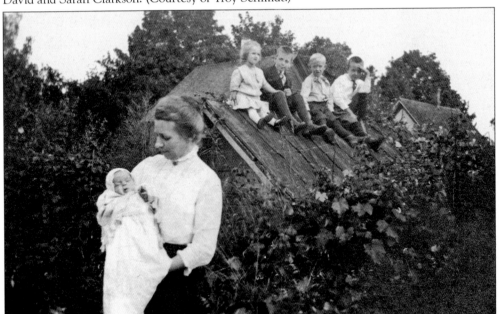

Next Generation, 1913. Anna Clarkson Dean holds baby June while the older Dean siblings pose on the rooftop of their mother's childhood home. From left to right are Louise, Bennett, Laurence, and Howard. The Dean children represent the fourth generation of Clarksons. They are the great-grandchildren of Northville pioneers David and Sarah Clarkson. (Courtesy of Troy Schmidt.)

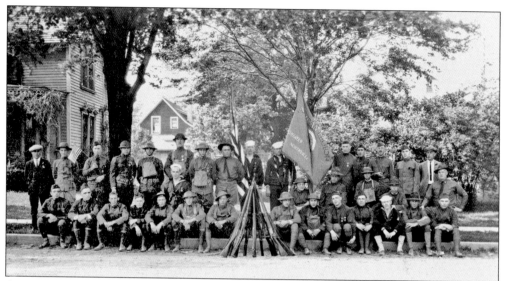

AMERICAN LEGION POST, 1923. Members of the Northville American Legion Post 147 pose in front of their headquarters on Dunlap Street. Among the veterans is Charles Schoultz, who is pictured on the left next to the stacked rifles. Schoultz was one of the World War I veterans who started Northville American Legion Post 147 and remained an active member until his death.

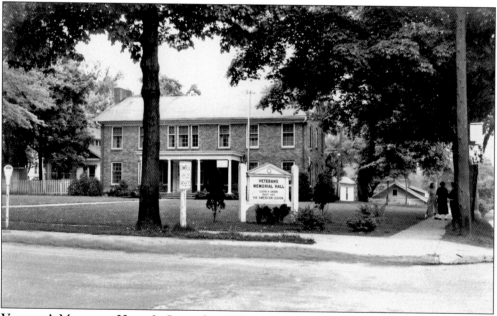

VETERAN'S MEMORIAL HALL. In September 1919, approximately 10 months after the armistice was signed ending World War I, the American Legion Post was formed. It was named for Pvt. Lloyd Green, who was killed on October 2, 1918, while fighting in France. The legion purchased the former home of pioneer Capt. William Dunlap at Dunlap and Center Streets in October 1944 and had it turned to face Dunlap.

WOMAN'S CLUB RECEPTION, 1946. Members of the Northville Woman's Club attend a reception at the Northville Library, the site of the club's regular meetings. Former Northville Woman's Club president and Northville Library founder Mary Lapham provided the organization with meeting space as a provision of her donation of the library building to the Ladies Library Association.

MOTHERS' CLUB OF NORTHVILLE, 1959. Organized in 1935 by 12 women who met regularly for "enlightenment and social activities," the club grew to 35 members and expanded its mission to providing Northville schoolchildren with a variety of enrichment programs. Pictured at a club meeting are, from left to right, (first row) Virginia Bale, Barb Yoder, Virginia Pauli, and Lou Angone; (second row) Betty Deal, Evelyn Mahoney, and unidentified.

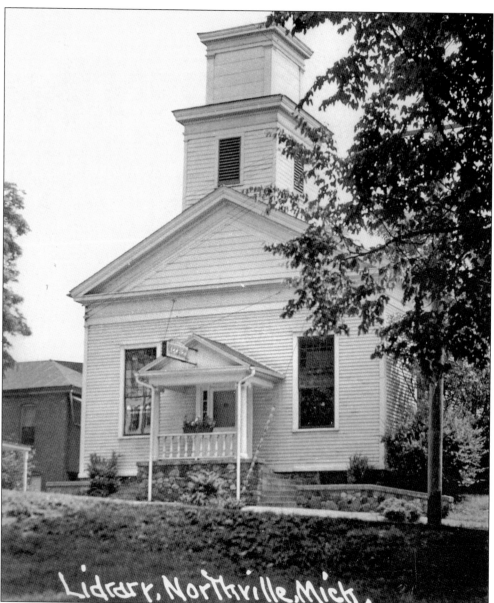

Lidrary, Northville, Mich.

MARY E. LAPHAM LIBRARY, 1934. The Northville Library's longest tenure was in the small church on South Wing Street built by the Presbyterian New School faction in 1845. The Laphams, who owned a homestead across the street, purchased the church sometime after it closed in 1849. In 1889, Mary Lapham was named chairman of the library organizing committee. Having donated the library's first 250 books, she was elected president of the Ladies' Library Association. She also was an active member and past president of the Northville Woman's Club and a Northville School Board trustee. In 1899, while living in North Carolina after completing medical school, Mary Lapham formally turned over the library building to the Ladies Library Association with a condition that the Northville Woman's Club be allowed to hold its meetings there. In 1904, the Ladies Library Association named the building the Mary E. Lapham Library. It remained the village library until 1964. It was the threat of its demolition that galvanized the Northville Woman's Club to begin a community-wide preservation effort.

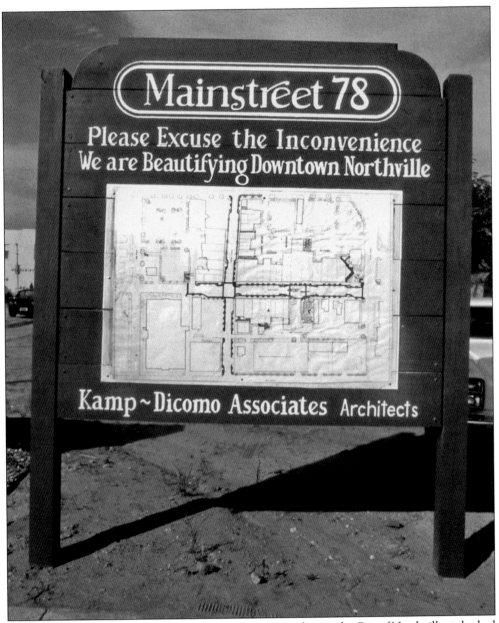

MAINSTREET 78. In what would ultimately be a four-year endeavor, the City of Northville embarked on a downtown renovation project in 1978 that rivaled anything in its more than 155-year history. An aging infrastructure and tired streetscape, the threat of a large suburban mall at its border, and a diminishing customer base pushed city leaders to ask voters for help in preserving Northville's downtown. The plan was ambitious. It also brought Northville statewide attention as one of the first municipalities in Michigan to use tax increment financing. Rejected by voters in its first ballot attempt in February 1979, city officials came back again six months later and won voter approval. Disruption, detours, and dust would prevail during the next three years. Nevertheless, on May 26, 1982, Northville unveiled a downtown that revitalized its historical character and preserved its iconic Main Street. It also spurred the private investment that made Northville one of southeast Michigan's most desirable communities.

Nine

PRESERVATION AND PERSEVERANCE

In the 1950s and 1960s, many of Northville's historic buildings were torn down to make way for a national chain grocery store, additional parking, and a road extension. By the close of the 1960s, entire blocks of 100-year-old homes were razed.

In 1970, a developer proposed to build a multistory, block-long indoor mall at South Wing Street extending from Main to Cady Streets—directly in the path of the old library building and home to the Northville Woman's Club, which had founded the Northville Historical Society in 1963.

Preservation-minded citizens and the historical society petitioned city residents and took their case to city hall. The council devised a plan to approach Ford Motor Company to donate the 12 acres it owned on Griswold Street, the site of Northville's first gristmill. Ford Motor Company agreed to gift the land to the city to "hold historical buildings." The old library and the former Hunter house, an 1845 structure and the last remaining house in the commercial district, were saved. Both structures were moved on July 6, 1972, to their new home . . . Mill Race Historical Village. In the nearly 40 years since its establishment, Mill Race has become a living museum of Northville's 19th century historic structures, including a former stagecoach stop, blacksmith shop, one-room schoolhouse, weaver's cottage, and interurban station. Its most recent addition is a general store.

While Mill Race Historical Village was taking shape, the historical society surveyed remaining structures in the city's core and found more than half of its buildings were far more than 50 years old, making the area eligible for historic district designation.

Another piece to the city's preservation efforts was added in 1978, when Northville became one of the first communities in the state to use tax increment financing and establish a Downtown Development Authority in an effort to improve its downtown. The public improvements spurred considerable private investment, and great efforts were made to reclaim the historic facades of the downtown's structures, a legacy that continues today.

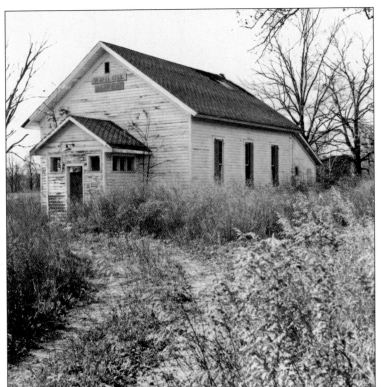

WASH-OAK SCHOOL, 1974. The one-room schoolhouse on Currie Road closed its doors in May 1966. It had been left abandoned for nearly a decade when Mr. and Mrs. George Rigby donated it to the Northville Historical Society. Each year, hundreds of schoolchildren experience a lesson at the Wash-Oak School while visiting Mill Race Historical Village.

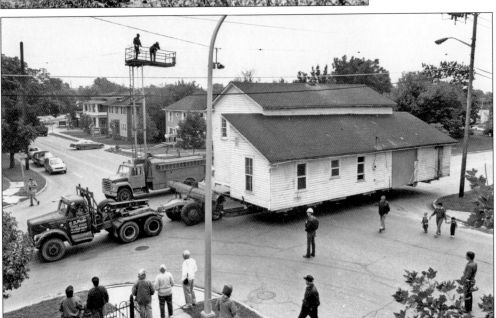

MOVING CADY INN, 1987. When the City of Northville purchased 315 East Cady Street, it offered the Northville Historical Society the building located on the lot. The saltbox style structure was a tavern and early stagecoach stop. Local legend has it that it was a stop on the Underground Railroad prior to the Civil War. This photograph shows the inn being moved across Main Street to Mill Race Historical Village.

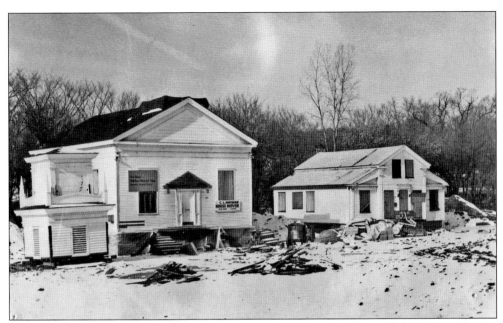

FIRST VILLAGE STRUCTURES, 1972. Once Ford Motor Company donated the acreage for the Mill Race Historical Village, the first two structures moved to the site were the New School Church, once the Mary E. Lapham Library, and the Hunter House, a Greek Revival house on Main Street. The moving of these buildings on July 6, 1972, marked the beginning of Mill Race Historical Village.

FINAL PIECE, 1973. Fitting the top of the New School Church are Burt DeRusha (left) and Jack Hoffman. Though the building had been used as a library for 70 years, the structure was restored to its original purpose as a church. Constructed in 1845 by the New School Presbyterians, it only served as a church for four years. The building is now used for weddings and meetings.

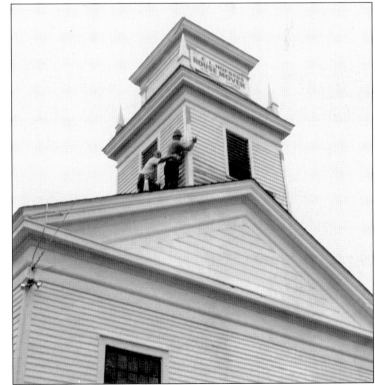

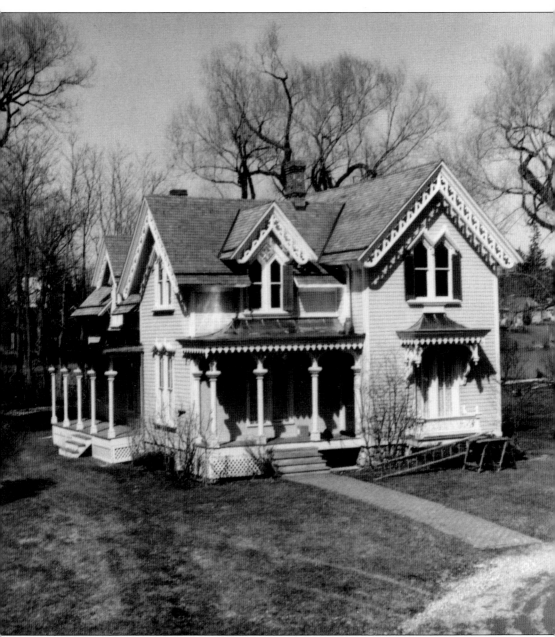

THE YERKES HOUSE, 1975. Located on the south side of East Cady Street, the Yerkes House was donated to the Northville Historical Society by Northville Downs. The house was built in 1873 by William Purdy Yerkes and his wife, Sarah (Cady) Yerkes. Both were descended from Northville's earliest settlers. William Purdy Yerkes (pictured on page 16) was an attorney, probate judge, and the first village president. The nine-bedroom home features traditional Gothic-style architecture. One of its most outstanding features is the black walnut freestanding curved staircase made by Northville craftsman Henry O. Waid. Before its move to Mill Race, the house had been a residence for many years, and needed considerable restoration to bring it back to its original period. It would take nearly five years of mostly volunteer labor to restore the Yerkes house.

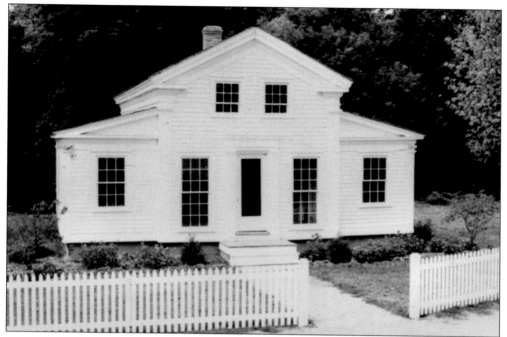

THE HUNTER HOUSE, 1972. Along with the New School Church, the Hunter House was the other original structure moved to Mill Race Historical Village in 1972. It is a classic Greek Revival with half gabled wings. Stephen and Mary Hunter built the house in 1851. The Hunter House now serves as a museum, furnished with pieces representative of its period of origin.

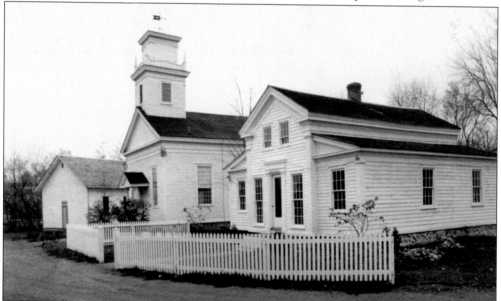

THE VILLAGE TAKES SHAPE, 1976. Only four years after securing the acreage for Mill Race Historical Village, four structures were moved to the site and restoration was well under way. The next decade would bring three additional buildings: the Cottage House, the gazebo, and the Hirsch Blacksmith Shop. The Cady Inn and an interurban waiting station followed. An 1850s general store is the newest addition.

MAIN STREET RESCUE, 2006. These photographs show the dismantling of an 1850s-era structure on Main Street to be moved to the Mill Race Historical Village as part of its "commercial district." The building is believed to be the last wood frame–constructed commercial building in downtown Northville. Unlike other structures that were moved in one piece, the general store was dismantled, and its pieces were stacked indoors until funds were raised to begin construction at its new site in Mill Race Historical Village. The money raised came from private donations as well as two matching grants by the City of Northville. Construction on the site started in 2008 with a grand opening scheduled in 2010.

FROM PIZZA PARLOR TO GENERAL STORE. This East Main Street structure had many tenants in its 150-plus year history, including the village's first library in 1889, a steam laundry in 1899, Wadsworth Bakery in 1931, Paul's Sweet Shop in 1958 (see photograph on page 93), the Old Mill Restaurant in 1961, and Little Caesar's Pizza in 1971. (Courtesy of Christopher J. Johnson.)

CHANGING FACADE, 1970s. This East Main Street building is hardly recognizable from earlier images of downtown. Many of the storefronts from the late 1950s through the 1970s were updated with exterior changes that covered the original brick and wooden trim work. Another change at that time was the addition of parking meters along downtown streets. (Courtesy of Christopher J. Johnson.)

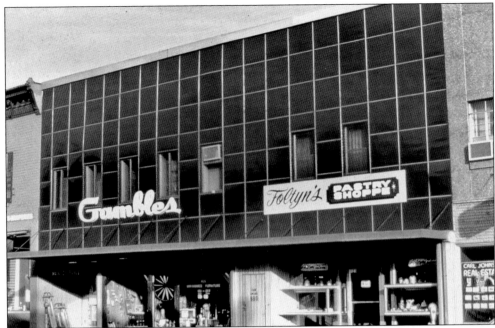

GAMBLES AND FOLTYN'S, 1970s. Gambles Hardware Store and Foltyn's Pastry Shoppe were housed in this building on the north side of East Main Street. The tiles on the building front were a deep green. In an effort to modernize their buildings, owners covered the Victorian period architecture that graced the downtown for nearly a century. The building to the left retains its original brick facade. (Courtesy of Christopher J. Johnson.)

NEAL BUILDING, 1970s. The Neal Building on the east side of North Center Street had housed many businesses, including the offices of the *The Northville Record* before the newspaper moved to its Center and Main Street location. The building to the right is now Orin Jewelers. (Courtesy of Christopher J. Johnson.)

MAIN STREET 78 BEGINS. This photograph of North Center Street shows the beginning excavation of the street. The key elements of the Main Street 78 improvements were the rebuilding of Main and Center Streets and their adjacent sidewalks. (Courtesy of Christopher J. Johnson.)

LEATHER SCRAPS AND INTERURBAN TRACKS. As this photograph of East Main Street looking west shows, excavation of the downtown streets uncovered some of Northville's early history. Among the items unearthed were wooden pipes that once carried the village's first water system, track pieces from the interurban, and scraps of leather tossed into the streets by Northville's multitude of 19th-century cobblers. (Courtesy of Christopher J. Johnson.)

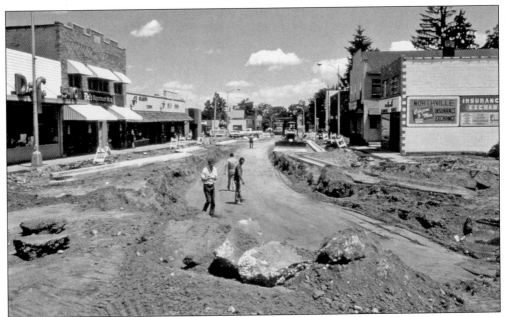

MAIN STREET TAKES SHAPE. Curbs already have been placed on East Main Street indicating the additional sidewalk width. In an effort to make the downtown more pedestrian friendly, sidewalks were widened on both sides of Main and Center Streets. Noticeably absent in this photograph are the overhead utility lines that were buried underground and the parking meters that were removed from downtown streets. (Courtesy of Christopher J. Johnson.)

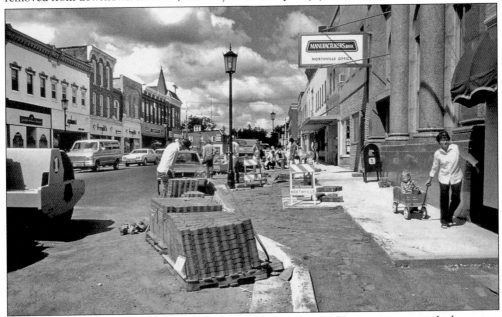

BRICKS AND MORTAR. Northville's 19th and early 20th century buildings were seen as the keystones of the Main Street 78 project. Enhancing the character of the buildings was the addition of new Victorian-style streetlights; landscaping, including new trees; benches; and bricked sections of sidewalks and crosswalks. In this photograph, pallets hold bricks that are ready to be placed along Main Street's sidewalks. (Courtesy of Christopher J. Johnson.)

MAIN STREET CLOCK INSTALLED.
One of the centerpieces of the Main Street 78 project was the addition of a 16.5-foot clock placed on a bricked island in the center of Main Street. In the 30-plus years since its placement, the clock has become an iconic symbol in Northville's downtown.

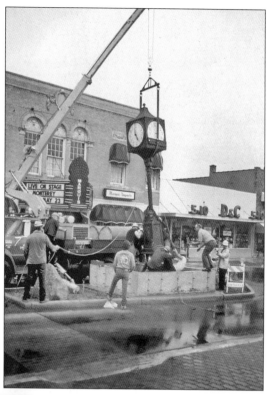

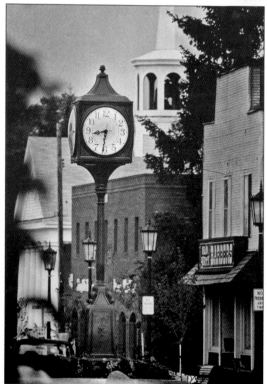

FACE TO THE FUTURE. The Main Street clock is silhouetted against a backdrop of Northville history. In the background is the steeple of the First Presbyterian Church, the community's earliest church, established in 1829. The building behind the clock is Long's Plumbing, in business since 1949. At right is a former wood frame structure built between 1830 and 1850 and now located in Mill Race Historical Village.

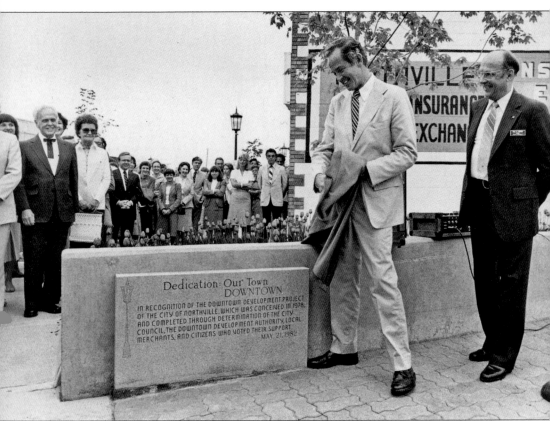

DEDICATION DAY. On May, 26, 1982, crowds gathered in downtown Northville for the dedication of Our Town Downtown, a commemoration of the citywide effort to revitalize and renew its historic downtown through the Main Street 78 project. Among the dignitaries gathering on Main Street were Michigan governor William Milliken (second from right) with city of Northville mayor Paul Vernon. Milliken unveiled the plaque commemorating the project while crowds looked on. In the four years since voters approved the project, the city was already beginning to see the benefits of the public's commitment to the improvement plan. The downtown's makeover was bringing in new businesses such as MacKinnon's Restaurant, and building owners, with the assistance of the city's Historic District Commission, were restoring buildings to reclaim their original architecture. Main Street 78 has long been regarded as the catalyst that brought increased commerce to the city and an implosion of residential development to Northville Township.

MAIN STREET REVITALIZED. This photograph of the north side of East Main Street looking west toward Center showcases the improvements in the downtown streetscape. The bricked sidewalks, Victorian-style streetlights, center island clock, trees, landscaping, and benches are all posed against a backdrop of historic buildings now revealed in a new light. The Main Street 78 project helped reenergize the city's efforts to preserve its historic structures and thus its history. The improved downtown brought not only new businesses into the commercial district but new residents, who were buying and restoring historic properties in the downtown's residential areas. The housing market in the historic sector soared. The demand for downtown housing, coupled with the insurgence in development in Northville Township, meant an expansion of community services and schools. The Downtown Development Authority, incorporated during Main Street 78, continues to play a critical role in maintaining the economic viability of downtown. (Courtesy of Christopher J. Johnson.)

EAST MAIN STREET, C. 1980S. This image shows the south side of East Main Street looking west toward Center Street. A photograph of this same side of Main Street taken a century earlier is on page 27. Though partially obscured by the trees in this photograph, the two brick buildings in the 1880s image are still standing. One of those was the B. A. Wheeler grocery store, which was a mainstay in Northville for 43 years. The building continues to be maintained by the Masonic Temple Association, as it was when Wheeler built it. Lapham's Men's Store, which continued in operation until the 1990s, is also on the south side of East Main Street. Originally C. A. Ponsford's dry goods and notions business, the building is still owned by Charles Ponford's grandson Charles Lapham. It celebrated its 100th anniversary in May 2010. Though all of the wood frame buildings in the 1880s photograph are gone, the Northville Historical Society preserved that early legacy by rescuing the last of the frame-constructed commercial buildings. In 2010, the general store will open in Mill Race Historical Village.

THEN AND NOW. The last vestiges of early Northville encompassed this building on East Main Street. Its wood frame construction was the last of its kind in a commercial district dominated by Victorian-period brick buildings. Evidence dates the building to sometime between 1830 and 1850. The Northville Historical Society dismantled the building and moved its pieces to Mill Race Historical Village to reassemble it. It will be used as a general store and house an assembly room for civic groups. The wood used in this building most likely was milled at one of Northville's early sawmills, powered by the stream that runs through Mill Race.

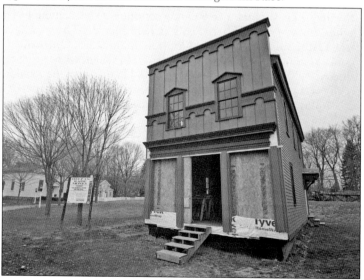

www.arcadiapublishing.com

Discover books about the town where you grew up, the cities where your friends and families live, the town where your parents met, or even that retirement spot you've been dreaming about. Our Web site provides history lovers with exclusive deals, advanced notification about new titles, e-mail alerts of author events, and much more.

Find Your Place in History.